The DK Art School

OIL PAINTING
PORTRAITS

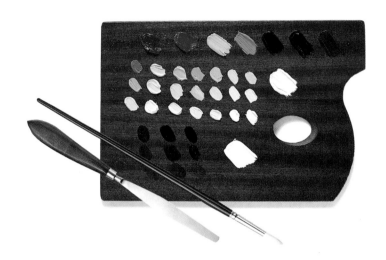

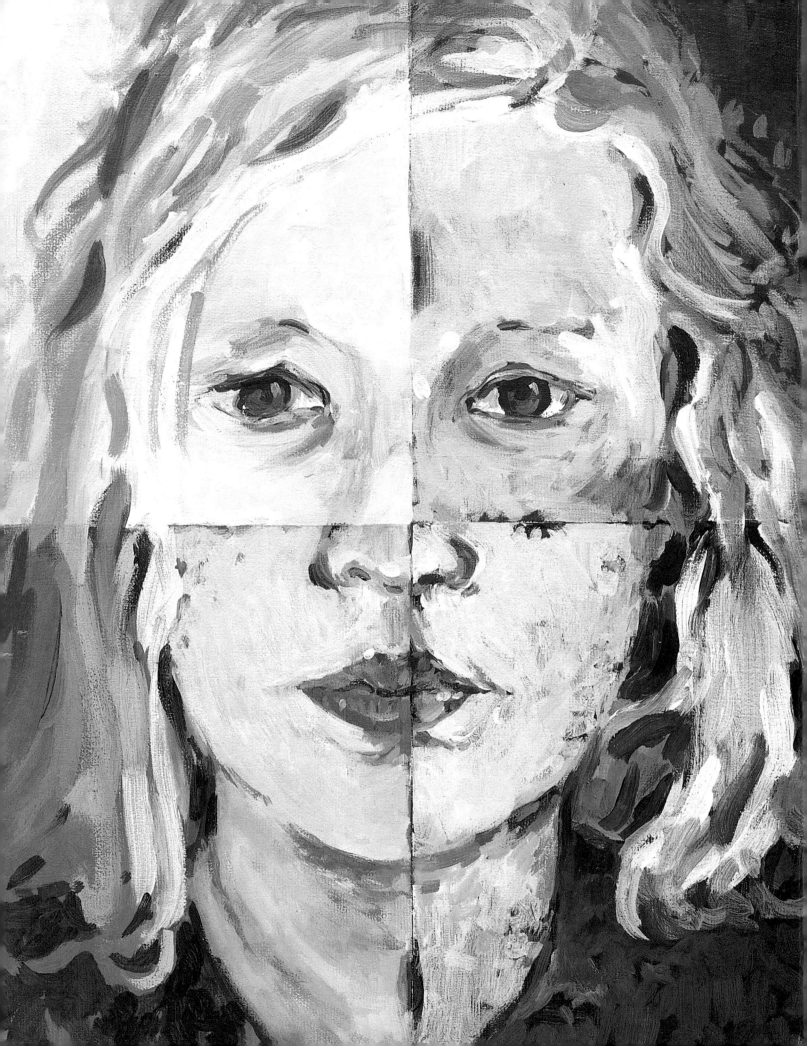

The DK Art School

OIL PAINTING
PORTRAITS

RAY SMITH

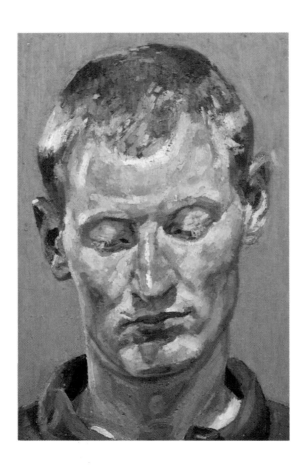

DORLING KINDERSLEY
London • New York • Sydney • Moscow
www.dk.com

IN ASSOCIATION WITH THE ROYAL ACADEMY OF ARTS

A DORLING KINDERSLEY BOOK
www.dk.com

Editor Louise Candlish
Art editor Claire Pegrum
Designer Dawn Terrey
Assistant editor Margaret Chang
Series editor Emma Foa
Managing editor Sean Moore
Managing art editor Toni Kay
DTP designer Zirrinia Austin
Production controller Helen Creeke
Photography Steve Gorton,
Andy Crawford, Tim Ridley

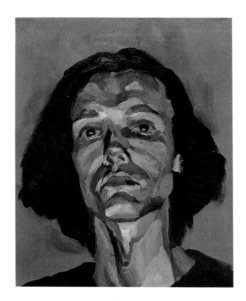

This DK Art School /Art book
first published in Great Britain in 1994
by Dorling Kindersley Limited,
9 Henrietta Street, London WC2E 8PS

2 4 6 8 10 9 7 5 3 1

Copyright © 1994

Dorling Kindersley Limited, London

ISBN 0 7513 0749 1

Colour reproduction by Colourscan in Singapore

Printed and bound by Toppan in China

CONTENTS

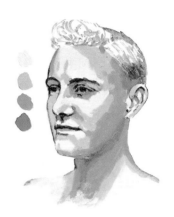

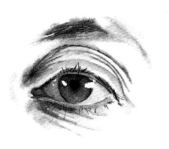

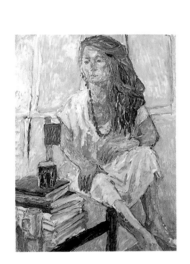

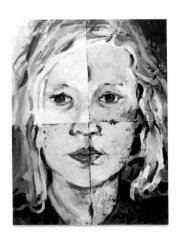

INTRODUCTION

FOR MANY PAINTERS, there is no more challenging task than to come face to face with another human being and attempt to make a representation that captures something of the spirit and physical likeness of that person. Making images of ourselves is part of our basic human nature; in all cultures and from earliest times we find evidence of a fundamental urge to represent what we are and how we look. If you are relatively new to painting, you may find the idea of producing an oil portrait intimidating. But it becomes easier once you realise that the person you see in the mirror or facing you across the studio is never exactly the same as the image on the canvas. In many respects, especially technically, painting portraits can be just as straightforward as any other area of painting.

Ancient images

From the early cave paintings in France and Spain, and from the ancient civilizations of Mexico, Peru or West Africa, there are remarkable examples of human beings coming to terms with themselves through the creation of powerful, perceptive images of the human face. Many of the images that have survived are in the form of sculpture, but there are powerful painted images on four-thousand-year-old Egyptian wall paintings and in the vivid Romano-Egyptian tomb portraits painted about 1,800 years ago.

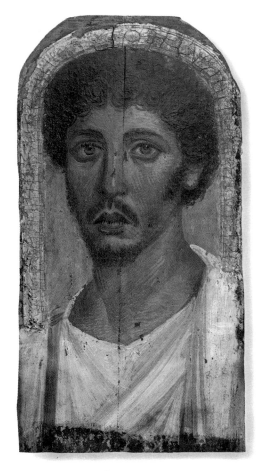

***Wax Portrait of a Young Man*, late 2nd century** A.D., *38 x 21 cm (15 x 8¼ in)*
In this Romano-Egyptian mummy portrait, the deceased youth gazes at us with a clear, calm look. The encaustic technique, involving the mixing and application of pigments in melted beeswax, gives the work an immediacy that belies its age.

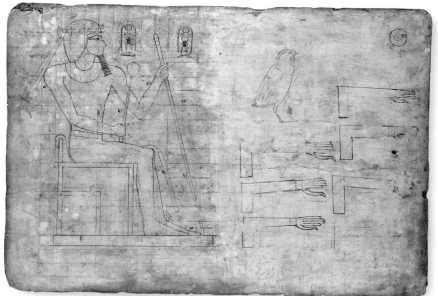

***Egyptian Drawing Board*, c.1502-1450** B.C., *35.4 cm (14 in) high*
In this Egyptian drawing on a wooden board, a careful geometric system of delineating shape and form can be clearly seen. The approach is entirely linear, yet a real sense of the three-dimensional form emerges in the figure. The use of a grid, marked in a different colour to the drawing, could enable the outline drawing to be transferred to a wall.

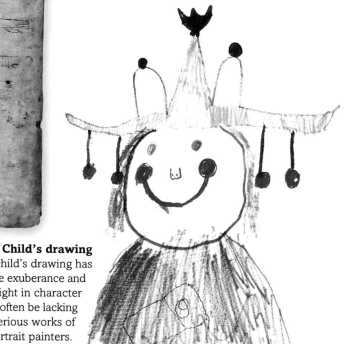

Child's drawing
This child's drawing has a simple exuberance and a delight in character that can often be lacking in the serious works of adult portrait painters.

Spontaneous expression

We can see in the images made by young children of their family and friends how children appear to capture so immediately the warmth and complexity of their feelings, in addition to creating pictorial signs which identify character and likeness. Children seem able to express themselves visually without any self-consciousness.

Many people lose touch with this spontaneous expression, but it is within us all and it can be retrieved. Artists who work from life know that there is an inevitable concentration and a seriousness about the process of making a portrait which marks it out from other areas of painting and seems to lock into a deep part of our nature. There is a mutuality about the process which invariably establishes a deep bond between artist and sitter.

Practical approaches

In this book, we discuss the materials and skills you might need to make portraits in oils, and we outline the stages by which you can proceed to an understanding of the various technical and interpretative approaches to the subject. Projects by a number of artists demonstrate a range of different ways to make portrait images in oils. Portraits by well-known artists are also included, illustrating important aspects of portraiture, such as composition, settings, mood and tone.

Drawings by very young children often have an astonishing intensity and a remarkable presence.

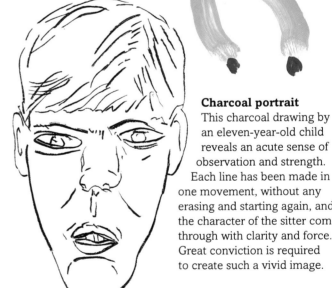

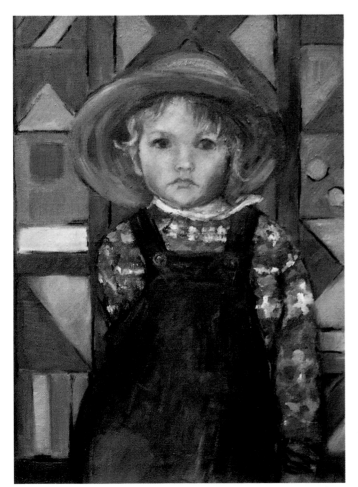

Charcoal portrait

This charcoal drawing by an eleven-year-old child reveals an acute sense of observation and strength. Each line has been made in one movement, without any erasing and starting again, and the character of the sitter comes through with clarity and force. Great conviction is required to create such a vivid image.

Ghislaine Howard, *Portrait of Jessie,* *64 x 86 cm (24 x 34 in)*
The world of the child is seen through adult eyes in this carefully considered commissioned portrait of a two-year-old girl. The subject is the daughter of a friend of the artist, and genuine affection for the child comes through the work, without sentimentality. A link with the family is established in the use of a backdrop which refers to the rugs made by the girl's mother; the simple geometric shapes also make associations with children's building blocks or bricks. There is a consistency in the artist's choice of palette, with its blues, oranges and ochres, which draws together all the aspects of the composition.

A BRIEF HISTORY

PORTRAIT PAINTING IN OILS began in the fifteenth century in the Netherlands, and oil-based paint was quickly favoured over egg tempera as the principal medium for portraiture. The slow-drying qualities of oil paint allowed further manipulation and blending once it had been applied to the surface of the canvas, while the translucence and resonance of oil colour offered a greater range of tones and colour effects than ever before. Portrait artists began to recognize that there was a new opportunity to express more accurately and vividly the special qualities of skin tones and the nuances of light and atmosphere.

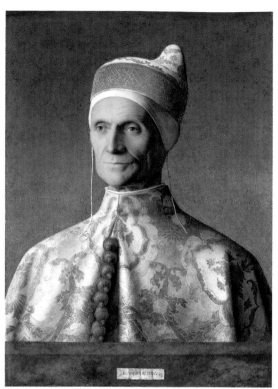

Giovanni Bellini, *The Doge Leonardo Loredan*,
*c.*1501, *61.6 x 45.1 cm (24¹/₄ x 17³/₄ in)*
Bellini's portrait is built up in layers, possibly on an egg tempera underpainting, and was made during the transitional decade from egg tempera to oil painting. The work shows all the austerity and maturity of this Venetian head of state. One senses the feeling of mutual respect between artist and sitter which has allowed Bellini to give full rein to his observational and technical skills.

JAN VAN EYCK *(c.1395-1441)* was among the great early protagonists of the oil medium for portraiture in the Netherlands. He achieved an extraordinary range of tones, with the deepest of shadows in transparent glaze colours and the clarity of bright light in opaque colours. In Italy, at the close of the fifteenth and in the early sixteenth centuries, artists such as Giovanni Bellini *(c.1435-1516)*, Raphael *(1483-1520)* and Leonardo da Vinci *(1452-1519)* adopted and mastered the oil medium, incorporating it into their unique style of portrait painting.

One of the most remarkable painters of this period was Albrecht Dürer *(1471-1528)*, whose oil portraits, painted in a thin, linear style, have a quality of observation that is genuinely timeless. As the sixteenth century progressed in Italy, there was a great liberation of style in the work of artists such as Titian *(c.1487-1576)* and Veronese *(c.1528-88)*. Their bold confidence with oils gives us a sense of really looking at people as they are.

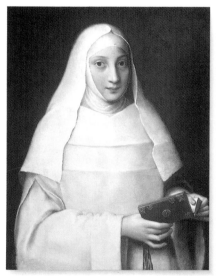

Sofonisba Anguiscola,
Portrait of the Artist's Sister in Nun's Clothing,
c.late 16th-century,
66 x 52 cm (26 x 20¹/₂ in)
Sofonisba Anguiscola was one of the first female painters of the Renaissance to achieve success and acclaim in her own day. The warm colours in this portrait help create a sense of real affection.

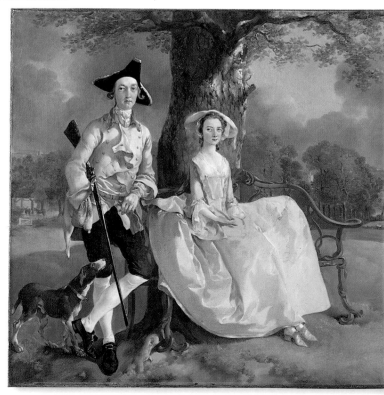

Thomas Gainsborough,
Mr and Mrs Andrews,
c.1750, *69.8 x 119.4 cm (27¹/₂ x 47 in)*
Gainsborough was one of the most successful society portrait painters of the eighteenth century. Here, he presents the assured young landowners in the midst of the rich farmland which sustains them.

**Toulouse-Lautrec, *André Rivoire*,
1901,** *55.2 x 46 cm (21³/₄ x 18 in)
An economical approach to oil portraiture is evident in this
work. The face emerges from a sketched background with
warm touches of opaque colour over a thin underpainting.*

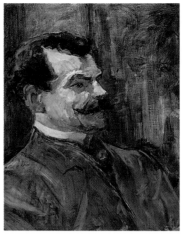

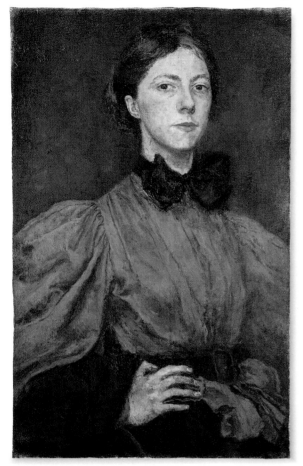

**Gwen John, *Self-Portrait*,
*c.*1900,** *61 x 38 cm (24 x 15 in)
Gwen John, who died in 1939, had
only one exhibition of work in her
lifetime and remained a relatively
obscure figure until recent times. This
self-portrait has an expression and
a demeanour, with hand on hip and
arched back, which is both candid and
proud in its self-possession. The head
is clear against an unfussy background,
and the dress, with its high neck,
bold bow-tie and full sleeves, adds
to a sense of defiance. The artist uses
a predominantly opaque technique,
with adjacent touches of pre-mixed
tints in low-key colours.*

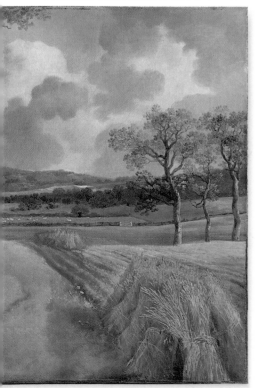

**Craigie Aitchison, RA, *Portrait of Naaotwa
Swayne*, 1988,** *61 x 50.8 cm (24 x 20 in)
Aitchison's painting is characterized by the
use of flat, strong colour, brushed thinly on
to the canvas so that it seems to become part
of the canvas itself. This portrait has been
pared down to the absolute essentials.*

A new confidence

Nowhere was the new confidence
and vigour more visible than in the
portraits of Velázquez *(1599-1660)*,
the seventeenth-century Spanish
painter. His brushwork is not
subservient to the image he is
trying to create, but autonomous,
allowing the characters in his
portraits to emerge with a spell-
binding immediacy. In the
Netherlands, Frans Hals *(c.1583-
1666)* was working in a similar way,
using lively brushwork to produce
portraits with an engaging presence.

The history of oil portraits is
a history of changing techniques
and approaches. The imprimatura
or toned ground, for example, was
used extensively up to the mid-to-
late nineteenth century. For artists
such as Rubens *(1577-1640)*,
Rembrandt *(1606-69)* and Van
Dyck *(1599-1641)*, working in the
seventeenth century, the mid-
toned ground provided a unifying
matrix underlying the brushstrokes
and allowed an economy in the
painting style that could not be
created with a white ground.

Changing styles

In the eighteenth century, the great
English portrait painter Thomas
Gainsborough *(1727-88)* used thin
washes of diluted oil colour in a fluent
technique that has left many well-
preserved and technically sound
portraits. His contemporary, Joshua
Reynolds *(1723-92)*, experimented with
unstable materials such as bitumen
and his works have suffered as a result.

Late nineteenth and early twentieth-
century developments led to an explosion
of stylistic diversity in portraiture, ranging
from the unparalleled intensity of colour
and expression in Van Gogh's *(1853-90)*
portraits, to the more monochromatic
Cubist remodelling of the human head
by Picasso *(1881-1973)* and Braque *(1882-
1963)*. In our time, artists continue to strive
to represent the truth of what they see.

OIL COLOURS

OIL PAINTS ARE MADE by grinding pigments with a vegetable oil such as linseed, safflower or poppy oil. The oil gives the paint its characteristic appearance and distinctive buttery texture. Pigments ground in oil have a particular depth and resonance of colour because of the amount of light the oil absorbs and reflects. Apart from providing this unique colour quality, the drying oils also protect the pigment particles and act as an adhesive in attaching the pigment to the ground. Oil paints can be opaque, such as Titanium White, or transparent, such as Winsor Blue. Opaque colours generally obliterate the colour they are painted over, while transparent colours can be applied in thin translucent films over dried colours for glazing and other effects.

Azurite and pigment

Recommended colours

Permanent Rose (T)
(Quinacridone Red)

Cadmium Red (O)

Cadmium Yellow Pale (O)

Winsor Green (T)
(Phthalocyanine Green)

Winsor Blue (T)
(Phthalocyanine Blue)

Titanium White (O)

Yellow Ochre (O)

Burnt Sienna (T)

Recommended colours for portrait painting
The following opaque (O), transparent (T), and semi-transparent (ST) colours are recommended: Cadmium Red (O) or Winsor Red (O), Permanent Rose (T) or Alizarin Crimson (T), Indian Red (O), Cadmium Yellow Pale (O), Cadmium Lemon (O), Winsor Yellow (ST), Winsor Lemon (ST), Lemon Yellow Hue (O), Transparent Gold Ochre (T), Winsor Blue (T), Cobalt Blue (ST), Ultramarine Blue (ST) or Cerulean Blue (ST), Dioxazine Violet (T), Quinacridone Violet (T), Cobalt Violet (ST), Winsor Green (T) or Viridian (T), Oxide of Chromium Green (O), Terre Verte (T), Titanium White (O), Flake White (O), Yellow Ochre (O), Raw Sienna (T), Raw Umber (T), Burnt Umber (T) or Burnt Sienna (T).

Cadmium Red pigment

Yellow Ochre pigment

Pigments
Originally derived from earths, minerals and vegetables, many pigments are now synthetic.

Mixing colours
In portrait painting, opaque colours are often used for light areas and transparent colours for dark areas. You can add a little white to a transparent colour to make it opaque. If, for example, you add a touch of Titanium White to transparent Winsor Blue, you will get an opaque blue. If you mix two transparent colours, such as Permanent Rose and Winsor Blue, you will make a deep, transparent colour.

DILUTING PAINTS

You will need to use distilled turpentine or white spirit as a solvent to dilute your paints. You can mix solvent with Stand oil (a thickened form of linseed oil) to make a painting or glazing medium. You can also buy oil painting medium, which is a mixture of the two. Be careful with solvents. Always use a screw-top dipper and replace the lid after dipping in the brush. If you are painting large areas using oil colour thinned with a lot of solvent, you should use an organic solvent mask to avoid any health risks.

Stand oil *Oil painting medium* *Solvent*

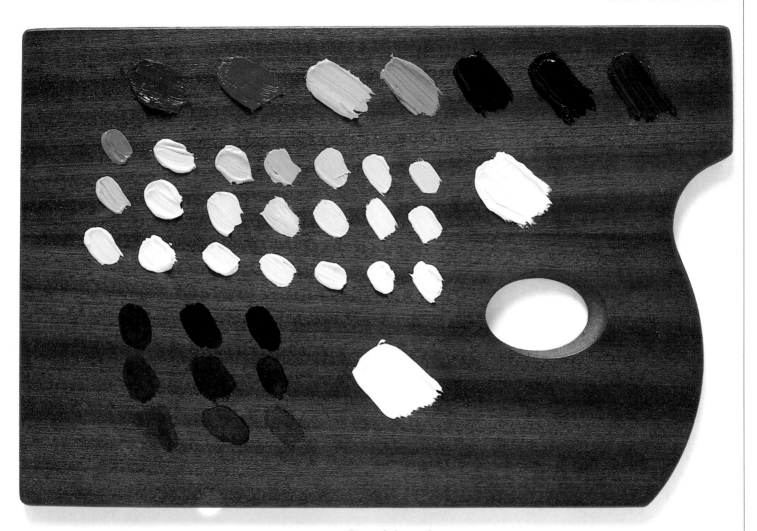

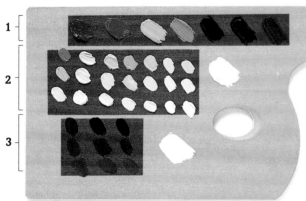

Pre-mixing colours

The preparation on your palette of a range of pre-mixed colours for flesh tones is a very sensible practice. It enables you to model the face with the same range of colours throughout at least one stage of painting, without having constantly to re-mix. Once the face has been modelled, the colours can be adjusted.

Opaque tints and transparent darks

Mix opaque tints and transparent darks from the recommended palette **(1)** of Permanent Rose, Cadmium Red, Cadmium Yellow Pale, Yellow Ochre, Winsor Green, Winsor Blue and Burnt Sienna. The pre-mixed opaque tints **(2)** are browns (BS, TW), pinks (CR, TW), pink-yellows (CR, TW, YO), warm pink-yellow-browns (YO, TW, BS) and cool pink-yellow-browns (YO, TW, BS, WB), greens (WG, BS, TW) and blues (WB, TW, BS). The transparent darks **(3)** are mixed from Permanent Rose, Burnt Sienna, Winsor Blue and Winsor Green.

Study in four flesh tones

Here, four flesh tones have been pre-mixed from Burnt Sienna, Titanium White, Cadmium Red and Yellow Ochre and applied to establish the main areas of tone and colour in an oil portrait. The visible joins between the colours can then be blended into an imperceptible fusion of tones by brushing across the join with a clean dry brush.

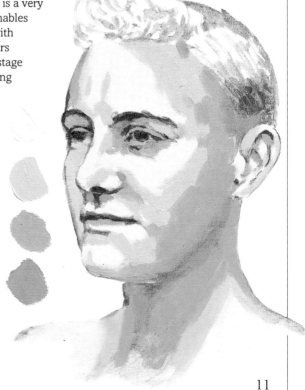

BRUSHES & BRUSHWORK

YOUR MOST IMPORTANT TOOLS are your brushes, and how your portrait looks depends greatly on the quality of these. There are two main types of brush: stiff-hair brushes, known as bristle or hog brushes, and soft-hair or sable brushes. Both types are also available made from synthetic fibres. Round, flat and filbert bristle brushes are commonly used in portrait work, for they are very good at moving paint around relatively large areas of the textured canvas surface. Soft-hair brushes are used for more delicate manipulations and for work on a small scale. Oil painting brushes traditionally have long handles, which allow the artist to work at some distance from the painting and see how it is developing as a whole.

Store your brushes in an upright container

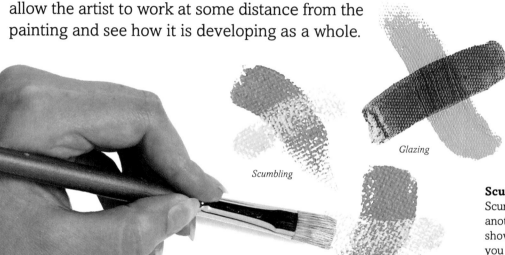

Glazing

Scumbling

Glazing
Glazing is the application of a thin film of translucent colour, mixed with a little oil painting medium, over another dried layer of paint. The colour below remains visible but has been modified by the glaze applied over it.

Scumbling and dry brush
Scumbling is brushing one colour loosely over another dried colour so that the colour below shows through in places. In dry brush work, you stroke stiff paint over the painted canvas so that the raised or textured areas of the canvas pick up the paint while the original colour shows in the troughs or indentations.

Size 3 round hog hair brush

Round hog brushes
Round hog brushes have a good paint-holding capacity. Use them to make rich, full strokes with thick oil colour or for dry brush effects.

Size 8 short flat hog hair brush

Flat hog brushes
Flat hog brushes make square-shaped strokes. These are often left unblended to give a direct, chunky look to an image.

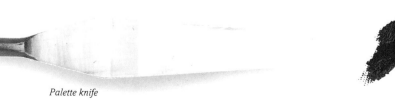

Palette knife

Painting knives
Painting knives are used to apply or remove and manipulate thick oil colour. You can also use them for scraped effects, known as sgraffito.

Painting detail

Use a round soft-hair brush for applying touches of colour within small areas. The point of a small round sable or nylon brush can be used to paint the most difficult shape. In a portrait, much of the detailed work on the features is done with a thin round sable brush, such as a size 2 (*see* pp. 60-61).

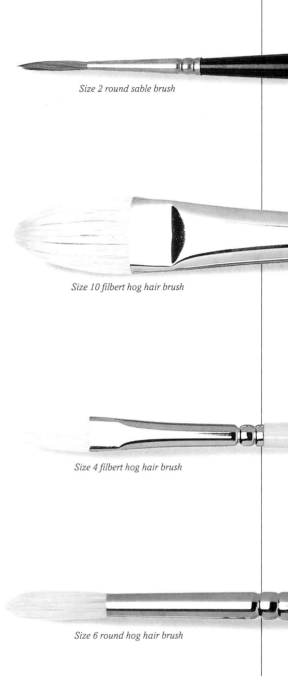

Size 2 round sable brush

Fine, delicate strokes

Impasto

Use a large filbert bristle brush to make broad, impasted strokes using thick paint either straight from the tube or loosely mixed. If you use a filbert, the start of the stroke will have the characteristic rounded look that many painters prefer to the harder square strokes of a flat brush (*see* pp. 32-33).

Size 10 filbert hog hair brush

Impasted brushwork

Thin colour

A small filbert is ideal for the application of a series of thin adjacent colours on to a white ground. The strokes retain their purity of colour and are given a characteristic and recognizable texture where the relatively coarse bristles scratch through the thin paint to the priming or colour beneath (*see* pp. 44-47).

Size 4 filbert hog hair brush

Strokes of thin colour

Broken colour

Here, a medium-sized round hog brush has been used to apply adjacent touches of opaque, unblended colour over a dark ground. The round brush allows the artist to apply enough thick, rich tints to sustain the intensity of colour over the ground, while controlling carefully how much paint is applied (*see* pp. 34-37).

Size 6 round hog hair brush

Unblended, adjacent tints

Fine blending

Clean brushes slightly dampened in solvent are used to blend adjacent colours or tones so that the eye moves imperceptibly from one colour to the next (*see* pp. 52-55).

Finely blended brushwork

13

SUPPORTS & GROUNDS

Y OU CAN PAINT on a rigid support, such as a board or panel, or on a flexible support, such as canvas. Oak, poplar or mahogany panels provide stable supports, though it is more common for artists to use plywood, hardboard and fibreboard panels. Unless you are painting on a small scale, however, it is easier to paint portraits on canvases, as they are lighter and more portable. The traditional choice is linen canvas, made from flax fibres which are long and strong, but there are also some excellent heavyweight cotton canvases. Whichever support you choose, each will have its own characteristic feel, depending largely on the particular ground or priming applied. This is a layer of paint used to seal the support and separate it from the oil colour. You can size and prime your own supports or buy them ready prepared.

A sturdy easel will allow you to work vigorously without fear of the canvas moving around.

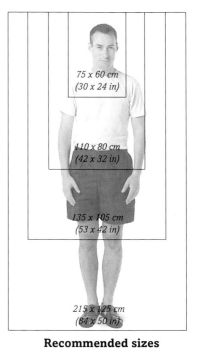

75 x 60 cm
(30 x 24 in)

110 x 80 cm
(42 x 32 in)

135 x 105 cm
(53 x 42 in)

215 x 125 cm
(84 x 50 in)

Recommended sizes
Choose the size of support to suit your portrait format. Sizes are not prescribed but you could try those shown above.

Smooth canvas *Rough board*

Rough canvas *Smooth board*

Rough and smooth grounds
On a smooth ground, such as a primed fine linen or a smooth panel, you can see every mark you make with great clarity. This is ideal for the modelling and blending of fine detail or for making loose, sweeping brushstrokes. A rough surface, such as a coarse grained canvas, will break up the brushstroke and give it a pitted or textured appearance. By this means, a craggy, chunky image can be economically produced.

Plywood

Hardboard

Medium-density fibreboard

Choosing a support
The texture of a linen canvas is dictated by the method of spinning the yarn and by the thickness or weight. A coarse canvas will give a good key to the paint and will provide a texture that has a significant impact on the way the painting looks. A smooth fine-grade linen is particularly suitable for highly detailed work. Cotton duck canvas is pleasant to use, but choose one of the heavier weights, preferably a twelve ounce or fifteen ounce one. Hardboard, plywood and medium-density fibreboard make good rigid supports, but only in small sizes; otherwise you will have to glue them to a rigid frame to prevent them from warping. Size and prime both sides of the panels to retain stability.

Fine linen

Coarse linen

Cotton duck 12oz

Stretching a canvas

When you attach your canvas to the stretcher frame, your aim is to make it as taut as you can, with an even tension throughout the canvas and without rucks or ridge lines. Stretcher pieces are obtainable from most art stores or from specialist suppliers. It is best to use stretchers with rounded edges, as this lessens the strain imposed on the fabric.

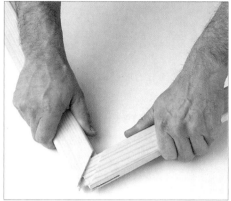

1 ▲ Assemble the four sides of your stretcher frame, using a rubber hammer to tap them together. Make sure the frame is square by using a set square or by checking that the diagonal measurements are exactly the same.

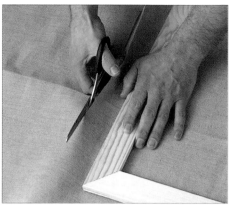

2 ▲ Lay the frame over a large piece of canvas and cut around it, allowing a margin of about 7-8 cm (3 in) on all sides to pull the canvas over the stretcher frame.

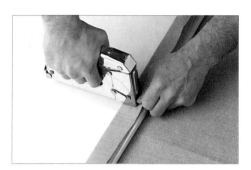

3 ▲ Pull the canvas over the stretcher frame by hand or using canvas pliers. Staple or tack the canvas down in stages (*see* diagram *below*), with two or three evenly spaced staples at each stage.

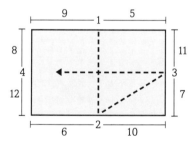

Staple the canvas in a specific order

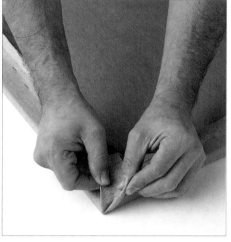

4 ▲ Make two folds in the canvas at each corner, pull one fold over the other and staple them to the frame. This will help maintain an even tension across the canvas.

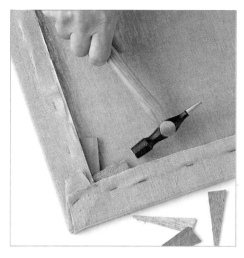

5 ▲ Tap a wedge into each corner of the frame. These are known as stretcher keys, and will help keep the canvas as taut as possible.

Sizing and priming

To size a canvas, apply one coat of warm size, made with 25-30 grams (1 oz) per litre (2 pt) of water, and allow it to dry. For sizing panels, apply one coat of glue size, made with 70 grams (2¹/₂ oz) per litre (2 pt) of water, and allow it to dry. Prime both canvases and panels with two coats of proprietary oil painting primer or a white oil-based undercoat for gloss paint. It is also possible to prime a rigid panel with an acrylic or PVA emulsion, such as an acrylic gesso primer.

1 ▲ Stir the size into the water and heat in a double boiler (or a pot with a saucepan) to avoid over-heating. When the size has dissolved, apply to the canvas with a large brush while it is still hot. This allows the size to penetrate the fibres of the canvas.

2 ▲ Allow the size to dry thoroughly before adding the priming. Use a large brush to apply oil painting primer or oil-based undercoat for white gloss paint. Apply the second coat by brushing at right angles to the first.

PRELIMINARY SKETCHING

ONE OF THE most important foundations of good portrait work is sketching. Among the best sketches are those made rapidly on a very small scale. It is useful to get into the habit of taking a sketchbook with you when you go to a concert or restaurant, or when you travel by train or go on holiday. Make studies of the characters you see around you, sketching people of different ages and nationalities. At home, make drawings of your own family while they are watching television or sleeping. It is best to draw people who are a fair distance away – about eight to twelve feet. This has two advantages. Firstly, you will not be disturbing your subject as you draw. Secondly, you won't be troubled by too much detail and so will be able to see the whole shape of the head and features clearly. This will help you sharpen up your powers of observation and will be invaluable when you come to work more formally with a sitter.

Drawing from life
Set up your family and friends for drawing from life and make several small-scale studies. Working with charcoal, conté crayon or pencil may help you to relax with your drawing in a way that you might not yet feel able to with brush and paint. Studies in pen and wash or watercolour are also very helpful preliminary stages to painting directly with oil colour on canvas.

Conté crayons
Conté crayons make strong, broad marks and give a lively, loose feel to a study. A round graphite stick is also ideal for more vigorous sketching.

Round graphite stick

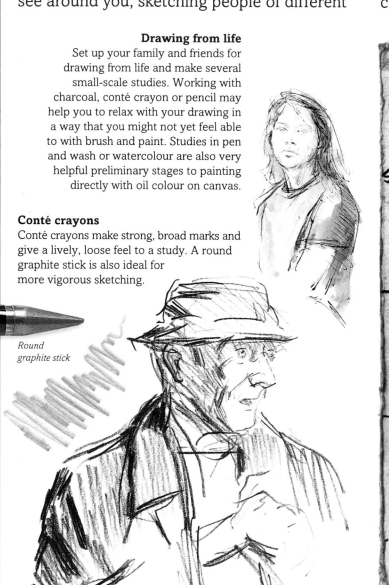

Sketchbooks
Sketchbooks invariably contain an assortment of images and words. Use your sketchbook as a diary of the people you see, drawing heads and faces from all angles. Make simple line drawings, letting the pencil or pen follow the profile or the shape of the head and features. Try to do this directly, without going over the same line twice or having to erase the line and try again.

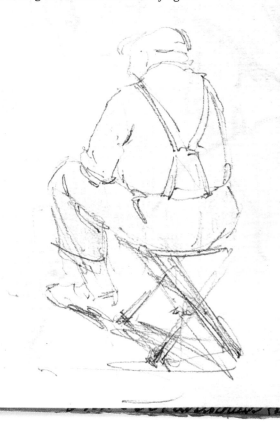

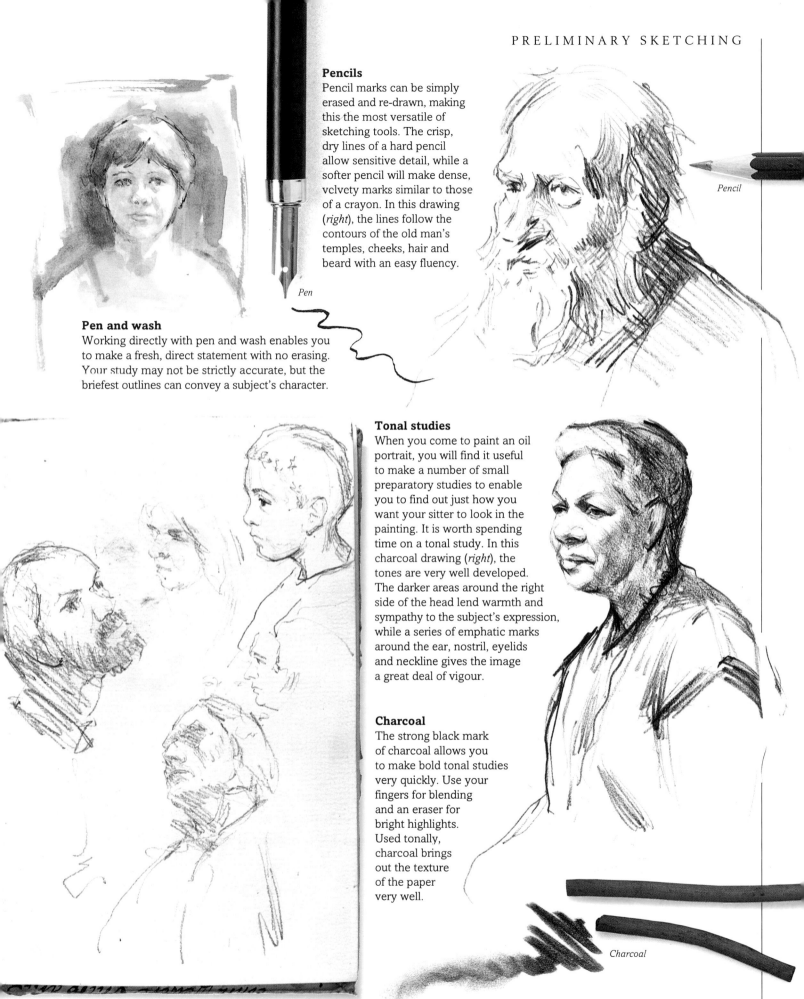

Pencils

Pencil marks can be simply erased and re-drawn, making this the most versatile of sketching tools. The crisp, dry lines of a hard pencil allow sensitive detail, while a softer pencil will make dense, velvety marks similar to those of a crayon. In this drawing (*right*), the lines follow the contours of the old man's temples, cheeks, hair and beard with an easy fluency.

Pen

Pencil

Pen and wash

Working directly with pen and wash enables you to make a fresh, direct statement with no erasing. Your study may not be strictly accurate, but the briefest outlines can convey a subject's character.

Tonal studies

When you come to paint an oil portrait, you will find it useful to make a number of small preparatory studies to enable you to find out just how you want your sitter to look in the painting. It is worth spending time on a tonal study. In this charcoal drawing (*right*), the tones are very well developed. The darker areas around the right side of the head lend warmth and sympathy to the subject's expression, while a series of emphatic marks around the ear, nostril, eyelids and neckline gives the image a great deal of vigour.

Charcoal

The strong black mark of charcoal allows you to make bold tonal studies very quickly. Use your fingers for blending and an eraser for bright highlights. Used tonally, charcoal brings out the texture of the paper very well.

Charcoal

TRANSFERRING AN IMAGE

L-shaped viewers made from cardboard

SOME PORTRAIT PAINTERS PREFER to go through a number of preliminary stages before committing to canvas, and such stages often take the form of preparatory sketches and photographs. When you come to transfer the image on to your canvas, you can do so freehand, but you may not find this accurate enough, particularly if you are working from a photograph. Specialized technical equipment, such as an epidiascope, an enlarger or a slide projector, will enable you to enlarge the contours of the face directly on to the canvas. If you do not have access to such equipment, you can use the time-honoured method of transferring an image by using a grid system.

Capturing an image

Photographs are a popular source of reference for portrait painting. Use your camera to try out a whole series of poses, looking from the right or left, up or down and trying full-face, three-quarter or profile views. Experiment with different lights, remembering that it is often better to use an image that has been taken out of the direct sunlight, as the shadows are less harsh.

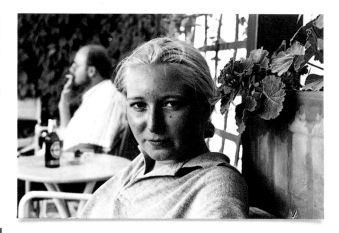

L-shaped viewers can be made quickly and easily; just cut out two right angles from thick, dark cardboard.

Using L-shaped viewers

Once you have chosen the image best suited to your proposed portrait, use L-shaped viewers to decide how much of the photograph you want to use in your painting. You can, of course, lose any extraneous detail or change the format by shading out the areas you wish to exclude with a pen. Here, the focus of the work is the head and shoulders of the girl herself, so this is the area that will be squared up and transferred to the canvas.

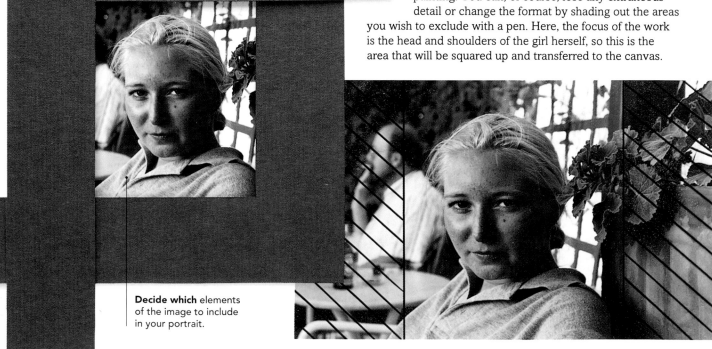

Decide which elements of the image to include in your portrait.

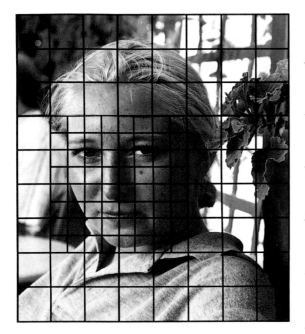

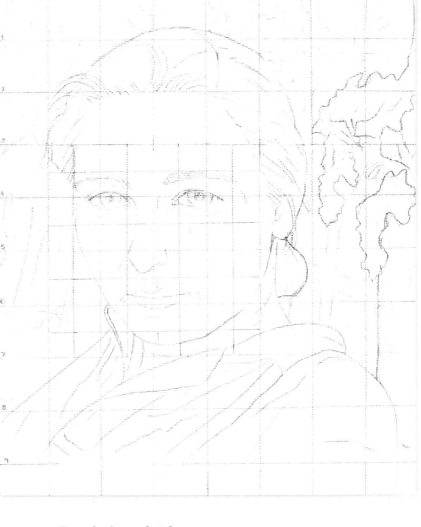

Squaring up the image

You can square up directly on to the photo itself, using a fine line pen and a set square. Use a scale of square that will allow you to transfer the broad areas, as well as any detail that you think relevant. Here, the features are squared up in smaller scale squares than those used for the main outline of the head. This allows you to be more accurate when you draw in the features. Mark an identical but larger scale grid on your canvas and work from square to square, drawing in the main details.

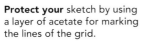

Protect your sketch by using a layer of acetate for marking the lines of the grid.

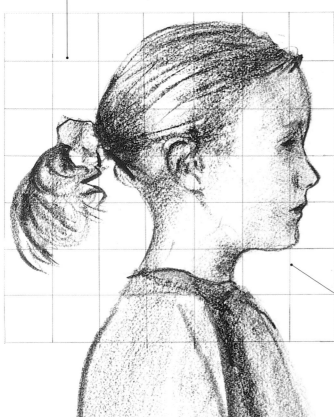

Transferring a sketch

You can transfer a sketch or study in a similar way. You may not mind marking a grid on the drawing itself, but if you want to protect the sketch, then square up a piece of thin acetate and superimpose it over the drawing. Here, the aim is to transfer only the broad outline of the profile.

The grid has been marked directly on to the pencil sketch with well-spaced squares.

OTHER REFERENCES

● Some artists combine sittings from life with working from photographs. If you have slides, there are commercially available electric viewers that allow you to refer to your slide in daylight while painting. The painting, below, is so large that it has been stretched on the studio wall during painting.

● There are now compact disc players that allow you to refer to a still photo on a television screen for as long as necessary. Your photographic dealer will transfer your prints to compact disc format for you.

GALLERY OF STUDIES

FOR MANY ARTISTS, preparatory studies are an indispensable stage in the process of making an oil portrait. They provide an opportunity to capture something of the mood or character you wish to develop in the painting. Such studies range from tiny, rapid pencil sketches to large-scale, fully modelled studies, and they often have a freshness that is lacking in the finished painting. Here, the versatility of pencil is revealed in the crisp, graphic lines of Picasso's drawing and the intensely worked study by Neale Worley. The powerful tonal range of charcoal and conté crayon is clear, as is the mood of spontaneity created by energetic pen and wash work.

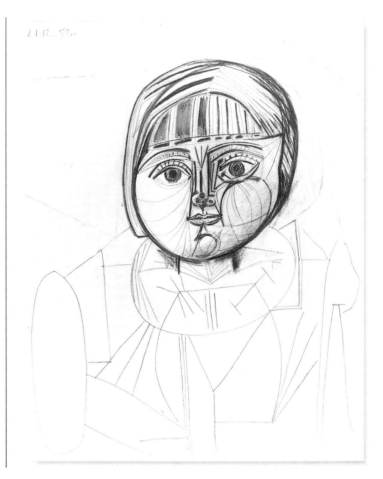

Pablo Picasso, *Portrait of Paloma,* 1952, *66 x 51 cm (26 x 20 in)*
Picasso's vigorous drawing has a childlike quality that echoes the youthfulness of the sitter. He has simplified and exaggerated the forms to give the drawing an almost diagrammatic appearance. In doing so, he has captured a real sense of the child's character. She has a clear-eyed, bright and alert look, with an open, untroubled expression.

Rembrandt, *A Young Woman Seated in an Armchair, c.*1654-60, *16.3 x 14.3 cm (6½ x 5¾ in)*
This pen and wash study is a work of quite exceptional intimacy and power, one in which Rembrandt has managed to convey a genuine sense of the moment. There is an edginess about the way the woman leans forward as if about to get up. Her hands are wrung together, held into her stomach, and her face is cast down. She is entirely self-contained.

This detail of the woman's face shows an exposed, sensitive expression, which leads us to speculate on the circumstances surrounding the drawing.

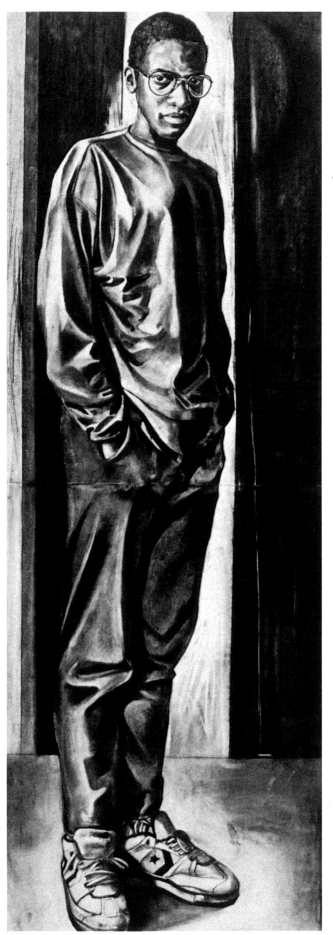

Polly Lister, *Elizabeth,*
32 x 31 cm (12¹/₂ x 12¹/₄ in)
This study has the kind of immediacy that charcoal can bring to a drawing, with its rubbed half-tones, areas of velvety shadow and highlights picked out with an eraser. The subject's face emerges softly from the grey ground. She seems to turn half away from the artist and her eyes do not quite connect with the viewer's. This slight sense of unease gives the drawing its authenticity.

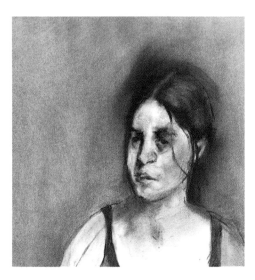

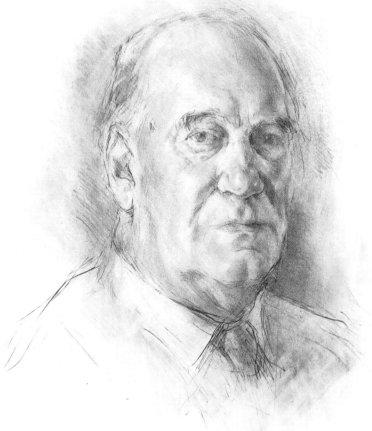

Mandy Lindsay, *Standing Figure,* *146 x 51 cm (57 x 20 in)*
This full-length study demonstrates how charcoal and conté crayon can be used to give a strong tonal rendering to a preliminary study. The drawing shows a complete range of tones from deepest shadow to brightest highlight, with all the folds in the clothes fully modelled. It is extremely useful to have this kind of study as a guide when painting.

Neale Worley, *Lord Pennock,*
56 x 46 cm (22 x 18 in)
Neale Worley's pencil drawing is the most rigorously worked and fully resolved of these studies. The effect of so highly representational an approach is to allow the character and maturity of the sitter to come through with genuine sensitivity and compassion.

21

THE HEAD

W HEN WE DRAW HEADS as children, we invariably make a circle and place the eyes, nose and mouth in the middle. We are, of course, most familiar with this direct, head-on view, because it is the one we see in the mirror. But a portrait artist needs to be aware of the shape of the head viewed from different angles and how this varies, often quite dramatically, from person to person. Certainly, it is helpful to study the anatomy of the human head, but it may be more practically useful to make a series of drawings and painted studies in which you concentrate on the basic planes of the head and on the way features change in appearance as we adjust our viewpoint.

Measuring with a pencil
When you are drawing, it can be useful to hold a pencil at arm's length and slide your thumb up and down it to measure the relative distances between features.

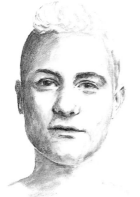

Full-face study

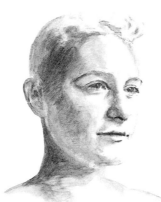

Three-quarter view (right)

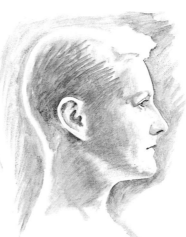

Profile study

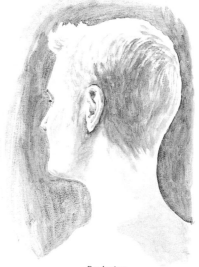

Back view

Monochromatic oil sketches
For painting monochromatic studies of the head from all angles, use a model with short hair. This will help you to see clearly the changing shape of the head. Lightly sketch the outlines in charcoal before using a small sable brush and thin transparent colour to draw in the features. Use a bristle brush with thin Burnt Sienna oil colour to sketch in the main tonal areas.

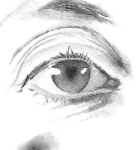

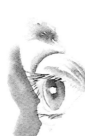

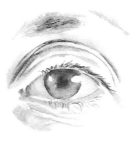

Eye studies
Concentrating on one particular feature, such as the eye, will add a degree of objectivity to your perception and help you to see parts of the face in a completely fresh way. Use watercolour, pen and wash or pencil to make a series of careful studies, viewing the eye from the side, three-quarters and full-face left and right.

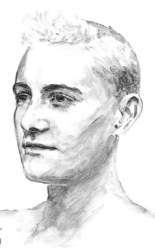

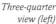

Three-quarter view (left)

Simple light effects
A series of charcoal studies will help you understand how light modifies the appearance of facial features. Here, bright light from the right throws the side of the face into sharp relief and highlights the contours of the temples, cheek and chin.

Unusual effects
Sometimes light can cast strange shadows, for example when foliage shields the face from direct sunlight. Here, strong light spots the face unevenly, creating sharp highlights on the bridge of the nose, the chin, forehead and neck.

A powerful medium such as charcoal is ideal for making studies of light effects.

STUDYING FEATURES

● Making closely observed oil studies of individual features gives you the opportunity to look at them quite separately from the head as a whole. Since you do not need to be concerned about getting a recognizable likeness of the face, you can relax and really examine the shapes and forms of each feature.

● You can experiment by taking photocopies of your studies and making montages, with the eyes close together or wide apart, for example, and in various configurations. Such exercises can teach us a great deal about the way we read people's faces.

Light from below
Bright light from a source below the head exaggerates the shadows and creates striking, rugged effects.

GETTING A LIKENESS

MAKING A PORTRAIT RECOGNIZABLE is rather a complex issue. What you see may not coincide with how your sitters see themselves or how others view them. Of course, we can use the grid system, photography or projection to help us lay down accurately the relative position of the features on the canvas. But whether or not the image has that indefinable quality that makes the character shine through the image is ultimately a result of the observation of the artist, the tractability of the materials and the particular chemistry of each painting session. If you want a model to practise getting a good likeness, use yourself. A self-portrait allows you to look really closely at head structure and the shapes and sizes of features without embarrassment.

Compare your sketches and studies with a snapshot to see if you have captured a good likeness.

A broad likeness

Half close your eyes to get a blurred image in the mirror and make a charcoal drawing. Losing the details in this way will help you to concentrate on the shape of the face and get a broad likeness.

Diagrammatic profile sketch in pencil

Tonal profile study in charcoal

Profile studies

Set up mirrors so you can see your own profile and plot an accurate image in pencil. Make a tonal version in charcoal or crayon.

Colour and tone

Make a series of oil studies in which you try to correlate what you see in terms of colour and tone with the marks you make on the canvas. Exaggerate each separate area of tone and colour a little to build up a patchwork of unblended brushstrokes which map out the planes and features of the face in relation to the highlights, middle tones and shadows. Juxtapose cool hues with warm ones so there is a lively pattern of colour in addition to an accuracy of tone. If you check your reflection frequently, and work boldly from what you see, you will be surprised how quickly a likeness begins to emerge.

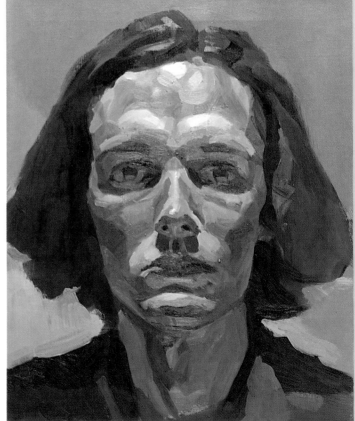

In this dark full-face study, the eyes fix us with a candid look.

Placing and scaling features
Make a series of careful pencil drawings in which you try to place and scale the features accurately in relation to each other. Draw lines as guides to the relative distances between each feature. The distance between the eyes is particularly crucial to the accuracy of a full-face image.

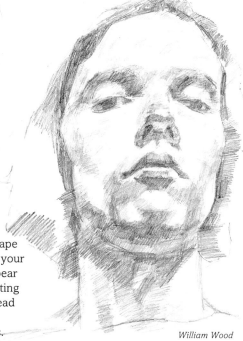

Adjusting your pose
Notice how your features change their shape when you adjust your pose slightly. Hold your head up, and your forehead and nose appear shorter, with the cheeks and chin dominating the image. If you look down, the nose and forehead appear longer. For unusual poses, incorporating tone can help you make more sense of the forms.

William Wood

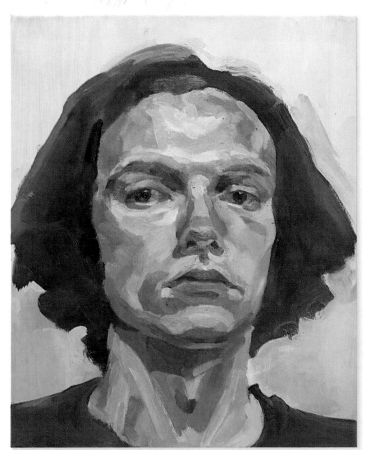

The yellows have been emphasized in this solid, wide-faced portrait.

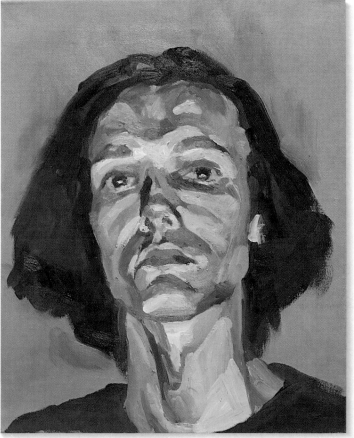

Warm pinks accentuate the lean, exposed look of this study.

SELF-PORTRAIT STUDY

T HE SELF-PORTRAIT allows a closer observation of your subject than you might get with a sitter, often resulting in an unblinking intensity unusual in other kinds of portraiture. This rapidly made study has been painted on a white ground, which keeps the colours fresh and reinforces the rather "exposed" look. The colours are relatively low-key, with the cool blue-greys complementing the warm orange-browns, while tonal contrasts are used to good effect with the pale face framed by the dark hair. The painterly integration of hair with background also helps push the face forward. By these means, our attention is focused on the face, its unresolved, somewhat nervous expression reflected in the flickering brushwork.

A screw-top dipper provides easy access to a small amount of solvent.

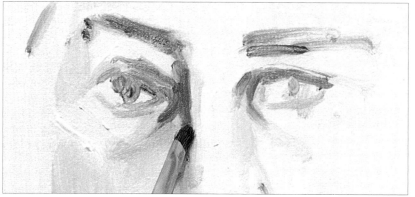

1 ◀ Set up a mirror close by and study your face carefully before beginning to sketch out the lines of your eyes and nose. Working outwards from the eyes, methodically stroke in each line with a small sable brush. Keen observation and accurate measuring at this stage will help you achieve a real likeness as the study progresses. Suggest the areas of tone around the eyes and nose with a small flat bristle brush.

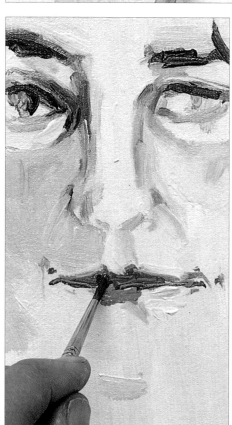

2 ◀ Using a small sable brush paint the outlines of the lips. They will immediately enliven the canvas, making a bold statement that will require little additional work. Check your reflection to assess the distances between features; how, for instance, the corners of the mouth align with the eyes, and what the distance is between the tip of the nose and the upper lip.

3 ▶ Once the shapes and measurements of the features have been established, add the line of the chin and begin loosely to suggest the hair. Use a large filbert bristle brush to build up texture rapidly, painting strong brushstrokes of blues, purples, and browns.

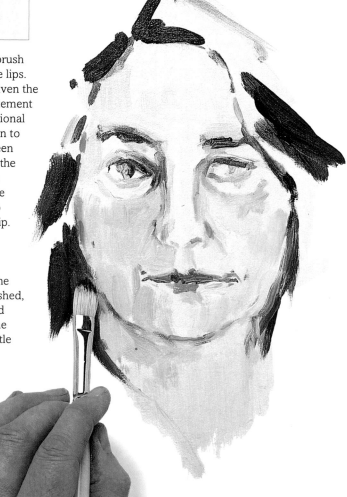

4 ▸ Now pay attention to the pale flesh tones, using a medium-sized flat bristle brush to blend wet-in-wet with gentle, flickering brushwork. Gradually thicken your paint mixes to create a sense of solid flesh. Switch to a small sable brush for the warm pink shadows at the sides of the nose and on the cheeks.

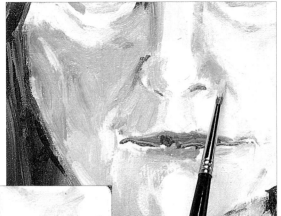

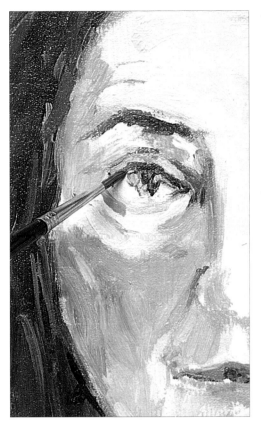

5 ▸ Pick out final details, such as eyelashes, and strengthen the lines of the eyes with a small sable brush. The gaze is direct and honest, intensified by the strong tones of the eyelids and brows. Finally, tone down the hair with a medium-sized flat bristle brush.

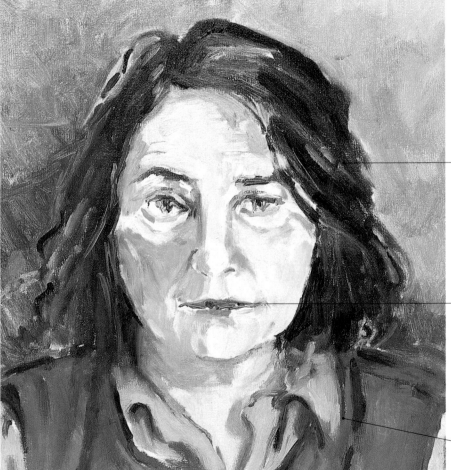

Self-Portrait study
The finished study has a stronger sense of immediacy and honesty than a more highly worked painting. The visible brushstrokes contribute to an unfinished, scrubbed background effect, which helps further dramatize the impact of the face itself.

The low-key browns and blue-greys of the hair are integrated with the grey background, pushing forward the face with its warmer tones and thicker paint effects.

The strong line of the mouth forms a triangle of dark tone with the bold lines of the eyes and eyebrows.

The cool blue-greys of the clothes are reflected in the irises of the eyes and the shadows around the nose, accentuating the use of a limited range of colours in the study.

Sue Sareen

Materials

Size 2 round sable brush

Size 1 short flat hog hair brush

Size 5 short flat hog hair brush

Size 8 long filbert hog hair brush

GALLERY OF SELF-PORTRAITS

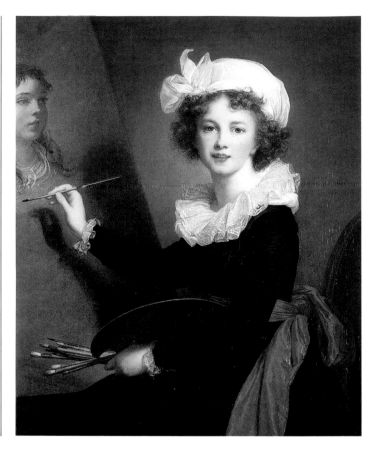

IN THE BEST SELF-PORTRAITS there is a truth and a directness which allows the character of the artist to be present in a quite intimate way. This element of self-exposure can be overplayed, but in these works there is a sense of restraint which lends dignity to the images. The tone and treatment vary dramatically, from the bright clarity and poise of the Vigée-Lebrun to the darker, low-key treatment of Tai-Shan Schierenberg's portrait, which pushes towards us with an almost physical presence. Philip Sutton's painting has the gravity that comes from a more mature artist, while Christopher Prewett's has the edginess of the young painter.

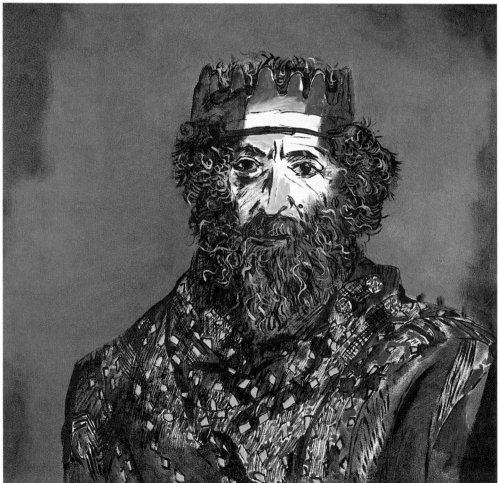

Elisabeth Vigée-Lebrun, *Self-Portrait,* **1791,** *99 x 80.5 cm (39 x 31³/₄ in) This self-portrait has a wonderfully fresh and open quality. The atmosphere is light, faintly self-mocking and full of enjoyment. The artist has taken great care over her choice of costume; the white turban and collar frame the face, with its clear eyes and direct expression, and contrast with the black dress. Cool background colours complement the warm flesh tones and the bold red sash and this reinforces the sense of poise and balance in the work.*

Philip Sutton, RA, *The King,* **1991,** *91.5 x 91.5 cm (36 x 36 in) Philip Sutton's self-portrait is one of a series in which he assumes different roles associated with the particular costume or headgear he is wearing. The costume is a device which liberates a mood or feeling within the artist's own character. It is an outward means whereby the artist can come to know and represent his inner feelings. Here, the crown evokes both king and clown or fool, and the bright colours of the crown are in opposition to the careworn, resigned look in the eyes. The rather diagrammatic method of painting, together with the cool, atmospheric blue, adds to a feeling of desolation.*

Tai-Shan Schierenberg, *Self-Portrait*
Small Head, *23 x 15.3 cm (9 x 6 in)*
This is an example of the kind of rapidly made alla prima self-portrait which ruggedly sketches out the broad structure of the face and gives one a real sense of the artist's presence. The paint is used with an impasted consistency throughout the work and there is a boldness in the decision-making and a lack of fussiness which gives the portrait its impact. A colour harmony of subtle low-key mixtures is used, and the cool background brings forward the warmer colours in the face. A strong use of tone shows the deep shadows in a face lit from above.

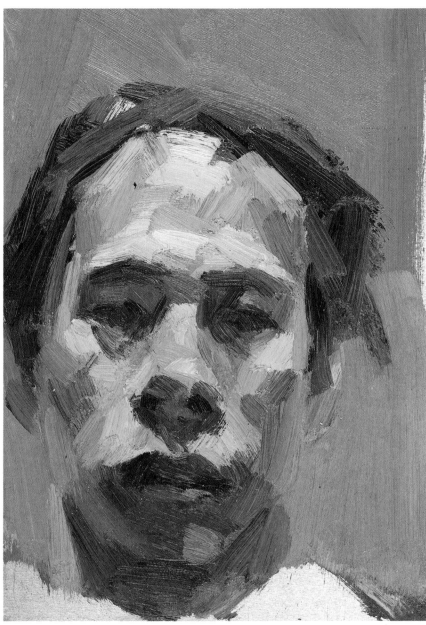

In this detail, the bold, vigorous brushstrokes have been made with a flat bristle brush. When a colour is overlaid wet-in-wet, as with the shadows below the cheekbone, the paint has a striated appearance where the two colours mix loosely together. Such additions of colour have to be boldly applied, otherwise a muddy effect can result.

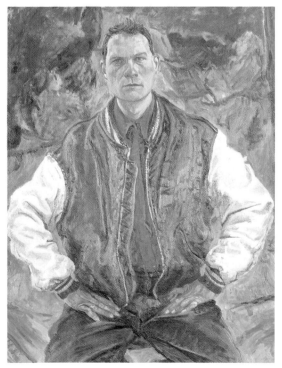

Christopher Prewett, *Self-Portrait,* *117 x 91 cm* *(46 x 35³/₄ in)*
This is a strong self-portrait which has, at first sight, a rather confrontational quality. It is, in fact, an extremely sensitive work in which we can follow the artist's efforts to come to terms with himself. This is clear in the way the brushstrokes flicker and move in an enquiring, nervous manner around the forms. The strong triangles of the arms and hands, solid on the hips, hold together an image constantly on the move.

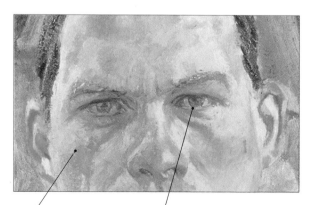

A limited colour range in the flesh tones of this detail gives a resolved feel to the head as a whole.

The eyes fix the viewer with a firm, candid look. They provide an area of sharp focus against a backdrop of shifting brushstrokes.

COLOURED GROUNDS

Study on a dark ground
If you work on a dark ground, you can use opaque colours to bring out the areas of the face which catch the light. This is an effective way of modelling images out of the shadows. Here, the contours of the eye are sketched in and will be built up until enough definition has been achieved.

THE ADVANTAGE OF WORKING on a white ground is that the white illuminates the paints in their true colours. However, there are very good reasons for painting a portrait on a toned or coloured ground. With a mid-toned ground, for example, you can use the ground colour as an intermediate tone between the lights and darks. This allows you to sketch in a well-modelled image very economically, using opaque mixes with white for the light tones and thin transparent dark colours for the darks. There are two main types of coloured ground: the toned ground, which is an opaque colour either incorporated into the priming or painted over it, and the "imprimatura", which is a thin layer of translucent colour laid over the white priming.

COLOURING A GROUND

- For an opaque ground, mix the chosen colour with white primer or white oil colour and paint it evenly over the canvas. Allow the paint to dry thoroughly.

- For a uniformly toned imprimatura (*above*), use a wide brush to apply horizontal strokes of thinly diluted oil colour. Brush lightly once again and the applied colour will settle to give an even appearance.

- For an imprimatura with variegated tone (*above*), mix the oil colour with white spirit to a fairly thin consistency and apply it with vigorous brushstrokes at various angles on to the canvas.

Choosing a coloured ground
Historically, it has been popular to underpaint flesh tones in Terre Verte, a natural green earth colour. The green can still be discerned in the shadows and acts as a complementary colour to the opaque warm flesh tones painted over it. In the preliminary stages for this portrait, the shape of the head and hands are given a similar toned ground using Oxide of Chromium Green, while the rest of the image, which is going to be predominantly in shadow, has been prepared with a warm Burnt Sienna imprimatura.

The transparent ground provides a warm background colour for the cool thin glazes that will be used for the deep tones of the costume.

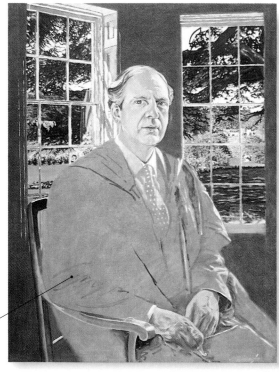

Preliminary modelling
The preliminary modelling for the hands has been achieved using white oil colour in a dry brush technique which brings out the basic form. The shadows have also been sketched in with thin Burnt Umber. The next stage is to paint the flesh tones with pre-mixed tints.

As the white colour is applied, the form of the hands quickly emerges from the green ground.

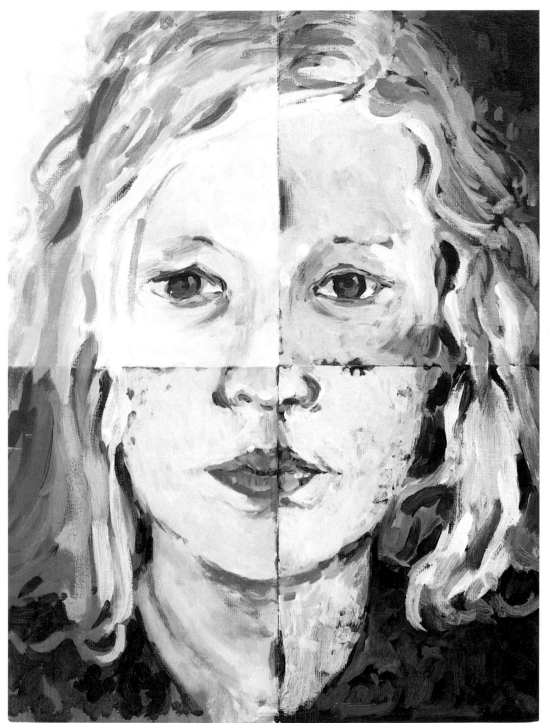

Study on toned grounds
Make experimental studies to find the best coloured ground.

White ground
A white ground illuminates colour and, being lighter in tone than everything you paint, makes your strokes appear darker than on a toned ground.

Red ground
A strong red ground warms up the image and pushes the face forward. The contrast between the blue in the eye with the red below is particularly strong.

Green ground
The green ground gives the warm pinks of the lips a richness and body. The muted tone also subdues the browns and ochres in the hair.

Blue ground
On a dark blue ground the colour effects are more brittle. The flesh tones need to be warmed up considerably to bring colour to the face.

Colour effects
An opaque or transparent brushstroke will have a quite different appearance on a transparent ground to that on an opaque ground. The tone of the ground will also greatly affect the appearance of the overlaid colour.

Opaque pink and transparent brown on a transparent Burnt Sienna ground.

Opaque pink and tranparent brown on an opaque Yellow Ochre ground.

Opaque pink and transparent brown on a transparent Burnt Umber ground.

Pink and brown on an opaque Chromium of Oxide ground.

BOLD COLOUR EFFECTS

THIS LIVELY PAINTING relies on the deep crimson imprimatura to provide an underlying ground colour behind and between the brushstrokes. This has the effect of integrating the work, creating a unifying matrix of colour. The red resonates with the near black, the blue-grey and the orange-brown of the face. The image is sketched out in a strong, diagrammatic way and then worked up with bold, chunky brushstrokes. The style of painting has a deceptive simplicity. There is an underlying tonal structure which holds the work together and the artist has avoided detail except where it is absolutely necessary. The eyes are the main focus of the face; they hold our attention, while around them the paint moves and turns. For all its boldness of style and economy of colour, the work remains a sensitive portrait.

A preliminary study in charcoal offers the opportunity to study your subject's features and assess the tonal range.

Materials

Ultramarine Blue

Titanium White

Cadmium Yellow

Alizarin Crimson

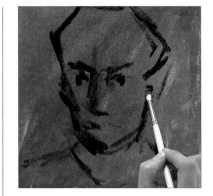

1 ▲ From a palette of four colours mix Ultramarine Blue and Alizarin Crimson to make a dark purple. Sketch in the features with a medium-sized round bristle brush.

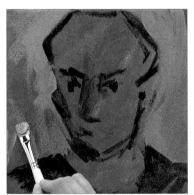

2 ◀ Begin blocking in the background with brisk strokes of blue-greys. The wet red ground shows through, giving a richness and warmth to the cool blues. Use a large flat bristle brush for this vigorous brushwork.

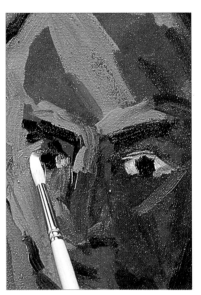

3 ▶ Establish the tonal structure of the face in logical stages. Firstly, use pale tones to suggest the fall of light on the left side of the face, then add dark orange-browns for the areas of shadow on the right side of the face. Apply broad, chunky strokes with a large filbert bristle brush.

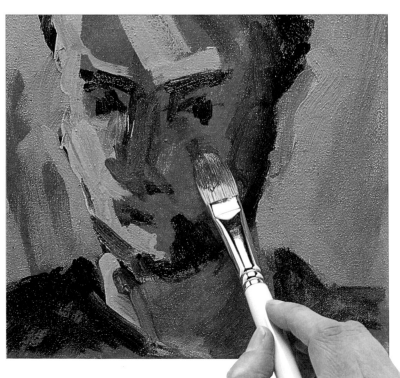

4 ▲ Work up the skin tones to give the face shape and form, before picking out the details of the features. Tint the whites of the eyes with Ultramarine Blue to reflect the background colour. Use a medium-sized round bristle brush for these finer strokes.

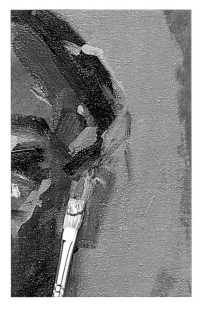

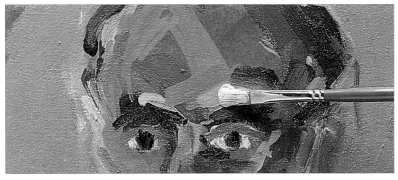

Materials

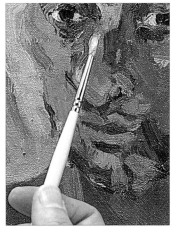

5 ▲ Integrate the face with the background by repeating the same blue-greys in the hair and flesh tones. Such repetition of a limited range of colour tints gives the portrait a close colour harmony.

6 ▲ Using a large flat bristle brush paint thick, creamy highlights above the eyebrows. This lively, impasted brushwork emphasizes the forehead and eyes, drawing the face forward to suggest a three-dimensional solidity.

7 ◄ Using a small round bristle brush add impasted yellow highlights to the nose to give it prominence. Finally, deepen the dark green shadows under the eyes, strengthening the bold rhythm of dark tone that runs through the portrait.

Charcoal

*Size 1 round
hog hair brush*

*Size 2 long filbert
hog hair brush*

*Size 5 round
hog hair brush*

*Size 10 long filbert
hog hair brush*

*Size 8 short flat
hog hair brush*

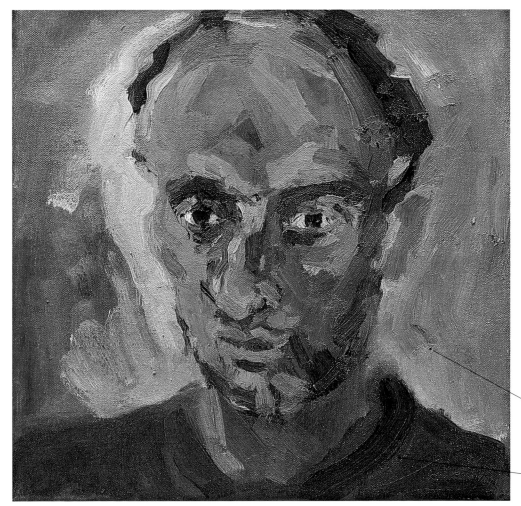

**Portrait on
a red ground**
The finished painting suggests a man of vibrant character and intense emotion. His eyes engage the viewer with a strong determination. The carefully crafted tonal structure of the painting works with the unifying warmth of the red ground to bring real life and energy to the subject.

The subtle, unfinished appearance of the background gives the face maximum impact.

The transparent red ground glows through the blues and browns, creating bold effects with a limited palette.

Rachel Clark

33

PROFILE PORTRAIT

Using a black ground
On a white ground, you usually begin by painting in the shadows, but on a black ground you paint "in reverse" and start by painting in the lights in pale, opaque colours.

B ECAUSE WE RARELY SEE our own profile, the profile portrait tends to have a naked clarity and objective truth that the full-face or three-quarter view might not reveal. That sense of objectivity characterizes this portrait, painted in an opaque technique on a black ground. As the painting progresses over the course of two sessions, the image emerges from the dark ground into a rugged three-dimensionality, as the artist applies adjacent rich, warm tints of opaque colour. If you look at the finished painting with half-closed eyes, you will see how the strength and completeness of the work stems from the artist's strict control of tone.

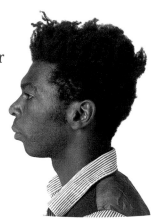

The sitter is positioned with the light source in front of him. His head is held high and the pose is strong and dramatic.

1 ▸ Draw in the brief outlines of the profile with thinned Yellow Ochre before applying the first layer of paint. Block in the hair with a well-diluted mix of Ultramarine Blue, Burnt Sienna and Titanium White, using a small round bristle brush. The opaque black ground provides a grainy surface that is ideal for black hair, allowing you to achieve texture economically.

2 ◂ Cover the whole face and neck with thin flesh mixes, juxtaposing warm and cool tints in a wide range of tones. For dark skins, deep tints of Burnt Sienna, Permanent Rose and Cadmium Orange with white provide rich, warm colours. Use tints of Winsor Green or Terre Verte for their cool complementary tones. A small round bristle brush, such as a size 3, is ideal for applying deft, chunky strokes of colour.

3 ▸ After painting the shirt collar and waistcoat, scumble a pale blue over the black background with a mix of Titanium White, Ultramarine Blue and a little Cadmium Orange. This will instantly give the profile definition. Once every area of the canvas is covered, leave the painting to dry thoroughly; that way you will avoid muddy effects later.

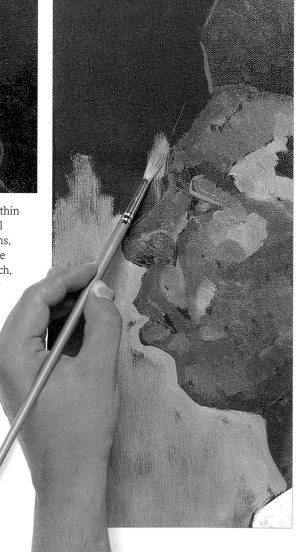

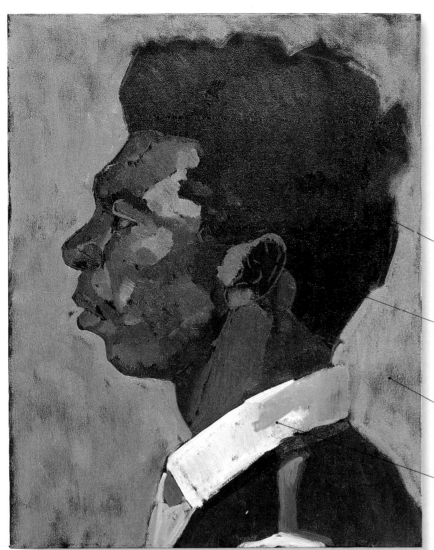

Half-way stage

At the end of the first session, the profile has a loose, energetic feel and the drama of the pose is already clear. Most of the basic tonal areas are sketched in and the tonal scale established: the collar represents the lightest note and the hair the darkest. In places, the tones are either still a little flat, such as the areas around the eye and nose, or rather too pronounced, as in the area of the temple. This is quite normal at this stage and will be resolved as the painting progresses.

The texture and colour of the ground are clear in the hair, which is painted with well thinned blues and browns.

The ear remains unpainted, for an error in its positioning and size early on would involve lengthy correcting in the second session.

The colour is more low-key or subdued than it will ultimately appear. High-key colour can be applied in the second layer.

The bright white collar is the lightest note in a carefully planned scale of tones.

Materials

Ultramarine Blue

Winsor Green

Cadmium Yellow

Yellow Ochre

Burnt Sienna

Titanium White

Cadmium Orange

Permanent Rose

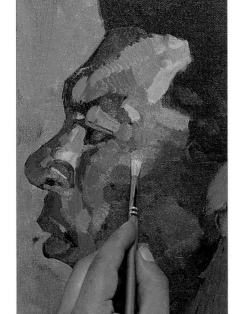

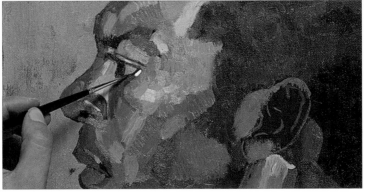

4 ◀ Once the first layer of paint has dried, begin building up colour more thickly with small, chunky strokes in a variety of opaque orange, red and green tints. Observe the fat-over-lean rule, whereby the oil content of the second layer of paint is greater than the first. This gives the new layer flexibility and avoids any cracking or flaking.

5 ▲ Use a small sable brush for the lines of the eye, adding a fleck of creamy yellow-white at the corner to indicate light shining on to the eye socket. The black ground can be used for the eyebrow and iris of the eye, allowing detail to emerge without the need to define edges too sharply.

6 ▶ Now paint the ear, paying close attention to its measurements. At the centre of the composition, the ear is a most important feature in a profile portrait and accurate placement is essential if a likeness is to be successfully achieved. Its addition has the immediate effect of making the portrait more three-dimensional. Use a small round bristle brush, such as a size 2, to paint the warm contours and dark shadows, before adding thick highlights with a small sable brush.

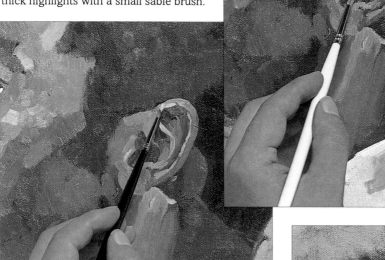

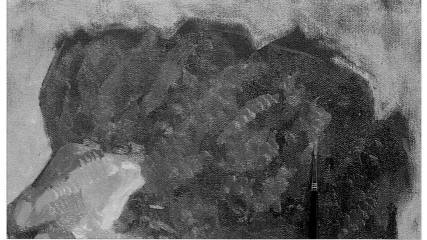

EARLY PROFILES

In Ancient Roman times, the art of painting was said to have originated when a woman drew the profile of the young man she loved by marking the lines of his shadow. Roman coins often bore profile images of heads of state and the tradition continues today.

HISTORY

Among the greatest profile images are the portrait of the Duke of Urbino in Piero della Francesca's Urbino Altarpiece in the Brera Art Gallery, Milan, Alesso Baldovinetti's *Portrait of a Lady in Yellow* in the National Gallery, London, and Filippo Lippi's *Portrait of a Man and a Woman at a Casement* in the Metropolitan Museum of Art, New York.

SILHOUETTES

The profile image is a marker of a kind of objective truth, and this may explain the tradition of having silhouette profiles made of all the members of a family through several generations.

7 ▶ Use a small sable brush for texturing the hair. The soft brush is ideal for applying loose, relaxed stokes of colour to suggest the fall of light across the thick curls. Apply purples and greens; these will appear pale against the transparent Ultramarine Blue, with much of the black ground still visible. This allows the distinctive thickness and body of the hair to emerge with the minimum of brushwork.

8 ◀ Using a medium-sized round bristle brush, such as a size 6, strengthen the lights and darks of the neck with long brushstrokes to capture the smooth muscular form.

9 ▶ Add a second layer of cool, pale blue-grey to the background, including a little yellow for the subtle integration of background with face. Blend the paint using a small round bristle brush, taking extra care where the background meets the outline of the face.

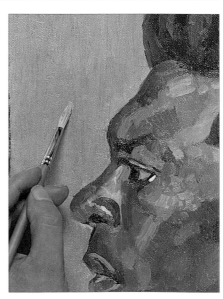

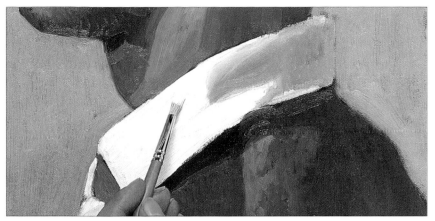

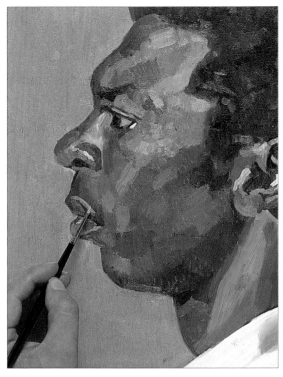

10 ▲ Using a medium-sized round bristle brush, paint a second, thicker layer of crisp blue-white to the collar with broad, sweeping brushstokes. This accentuates its stiff texture and, where the light catches the front of the collar, makes a powerful tonal contrast with the dark brown waistcoat. The smooth white also warms the dappled reds of the flesh tones.

11 ▶ Pick out final details, such as the highlight on the upper lip, using a small sable brush to apply colour finely. Observe your sitter keenly, noticing that the soft contours of the lips do not catch light as sharply as the clean, defined edges of the ear and nostril. Take time to get the final touches exactly right.

Profile on a black ground

The finished portrait gives a good solid impression but has not been over-refined. One might imagine the artist using this as a study for a larger painting of the sitter. Colours are generally cool in the highlights, with alternating strokes of warm and cool colours in the lights and shadows. The overall warmth of colour is concentrated in the upper features, while the hair and cheek are predominantly cool. The painting retains a loose, chunky feel in the brushwork that gives it movement and life.

Controlled brushwork has kept the highlights pure and unsullied by the surrounding colours.

The fall of light has been closely observed; it shines across the top half of the head, over the temple, eye and nose, then down across the ear, neck and collar.

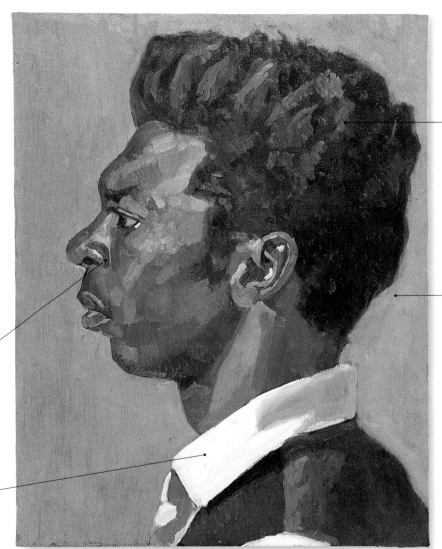

Nahem Shoa

Loosely applied highlights of opaque purple give the hair a distinctive texture and body.

A second layer of cool blue-grey helps keep the background flat and solid, while warming the flesh tones of the face and neck.

Materials

Size 2 round hog hair brush

Size 1 round sable brush

Size 3 round hog hair brush

Size 6 round hog hair brush

GALLERY OF COLOUR

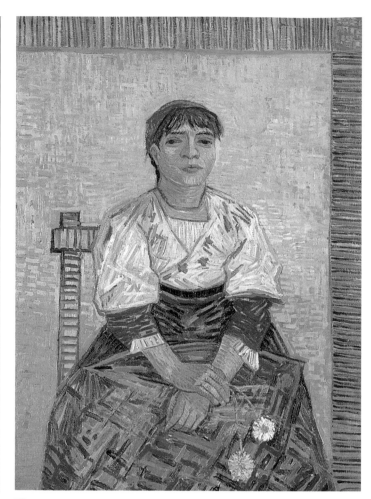

MUCH OF THE ATMOSPHERE of a portrait is generated by the way in which colour has been used. It can make a painting shine with light and warmth, as in Van Gogh's *L'Italienne*, where yellow, orange and orange-red are complemented with touches of blue and green, or it can create a tender, gentle atmosphere as it does in Leonard McComb's portrait of his mother. In Andrew Tift's *Birmingham Bus Driver*, colour causes the work to vibrate with a strong intensity, while in Roger Oakes' self-portrait, colour flows around the figure and creates a rich textural interweaving between figure and ground. In Polly Lister's painting, the red glows with a powerful sense of urban drama behind the artist in his black jacket.

Vincent van Gogh, *L'Italienne*, 1887, *81 x 60 cm (32 x 23³/₄ in)*
The extraordinary sense of directness that characterizes the portraits of Van Gogh is present in this painting. Here, the woman's head is the focus of the work at the apex of a triangle which provides the solid structure for the figure. It is separated from the richly textured passage of colour in the lower half of the figure by the paler tones of the blouse. The blue of the chair back sets off the warm orange-yellows, while the green in the whites of the woman's eyes seems perfectly natural.

Leonard McComb, RA, *Portrait of the Artist's Mother, Mrs Delia McComb*, 1993, *91.5 x 76.2 cm (36 x 30 in)*
There is a genuine sense of tenderness towards the subject in this work. The artist has built up the image with controlled touches of opaque colour against the dark ground. He has used tints of purple and green, complementing them with warmer tints of orange-yellow and pinks, and the face emerges as a delicate and dignified image. The scarf, painted in deeper tints, gives body to the figure, spanning the two vertical sides of the canvas.

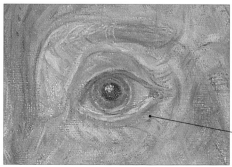

The eye has been beautifully observed and drawn in this detail. There is a far-away look and a watery physicality that shows the artist's concern to paint his sitter exactly as she is.

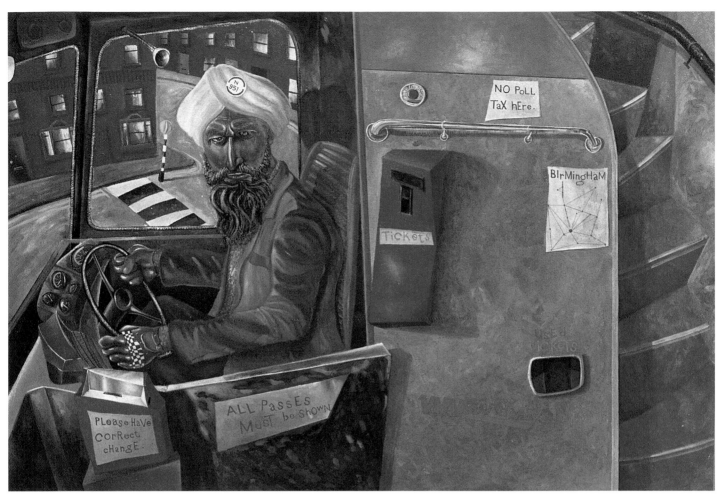

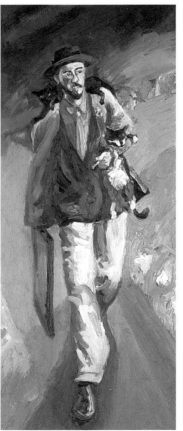

Andrew Tift, *Birmingham Bus Driver,*
54 x 37 cm (21¹/₄ x 14¹/₂ in)
This vigorous portrait brings together the driver and his bus in an extremely effective composition which links the various spaces of the interior of the bus with the world outside it. The painting relies for much of its effect on the contrast between orange-red and its complementary blue.

Roger Oakes, *Self-Portrait with*
Fatty-Grey and Sam, *76.3 x 30.5 cm (30 x 12 in)*
This rapidly painted study has a looseness and freshness in the brushwork and use of colour which overrides some slightly less comfortable areas, such as the hand and the nose. The artist has managed to retain the purity of individual hues within the rich impasted mixtures.

The background colours have been added after the figure has been painted. These warm oranges and pinks, boldly applied, bring the painting to life.

Polly Lister, *Vegetable Monitor,*
76¹/₂ x 76¹/₂ cm (30 x 30 in)
The strong colour effects of this work are created by the dramatic juxtaposition of red with black. The face has been painted almost monochromatically, using tints of purplish red and touches of the background red.

ARTIST & SITTER

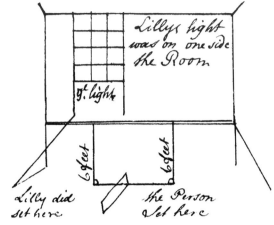

Positioning the sitter
In his "Notes on Painting" (1673-1699), William Gandy describes how the seventeenth-century painter, Sir Peter Lely (Lilly), set up his studio for portrait work. The sitter would be positioned about 1.8 metres (6 ft) into the studio from the principal source of light, a large, high window.

The quality and direction of light is an important aspect of a portrait.

SITTING FOR A PORTRAIT can be just as arduous and demanding as painting one. In fact, it makes a lot of sense to put yourself into the role of model at least once to get an idea of the concentration and effort it involves. Many sitters are self-conscious, and it is often better not to let them know which part of the portrait you are working on. Always give sitters regular rests, so that they can get up, wander around and take refreshment. They may even like to look at the progress of the portrait, although some artists prefer not to show their work to the subject until it is finished. However, a kind of complicity can develop between artist and sitter if both are actively involved in the project, and this can be very positive as the painting progresses.

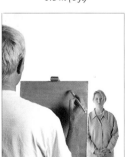

1.8 m (6 ft)

Recommended distances
At first, you may make the mistake of working too close to your sitter to have a clear view of the whole area you wish to feature in your portrait. About 1.8 metres (6 ft) is an appropriate distance from your subject if you are painting a head and shoulders portrait, three metres (10 ft) is sensible for a half-length portrait, while up to 5.5 metres (18 ft) is traditional for a painting of a full-length figure.

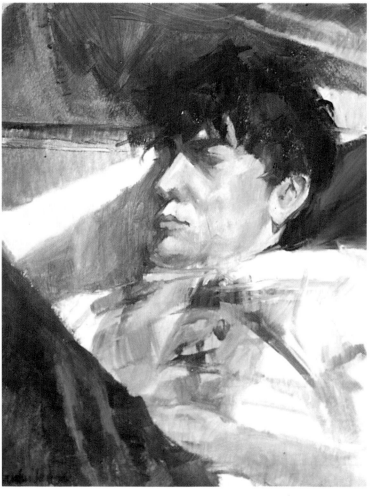

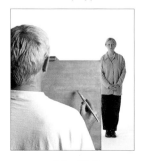

3 m (10 ft)

Informal situations
Although it is helpful to bear in mind the recommended distances between painter and sitter, there are many informal situations when such guidelines are neither appropriate nor practical. You may, for instance, find yourself happily painting a couple of feet away from someone slumped in a chair, with bright afternoon sunlight casting deep shadows across their face. These images (*right*), show a relaxed and informal approach to portraiture, in which the artist responds to the unselfconscious, casual poses of the sitter.

5.5 m (18 ft)

The artist is positioned about 1.2 metres (4 ft) from the sitter.

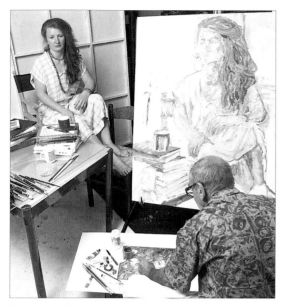

Eye levels

It is very important to establish the appropriate eye level of your sitter, for this will have a great effect on the tone of your portrait. Very often, the eye level of the artist and that of the sitter correspond. It is useful to make studies in which you experiment with eye levels to exaggerate the height of your sitter.

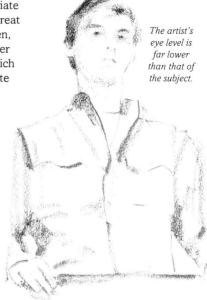

The artist's eye level is far lower than that of the subject.

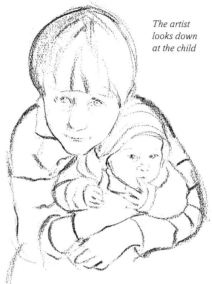

The artist looks down at the child

Large-scale work

When you are working on a large scale, it is useful to set up the canvas at an angle which allows you to see the model clearly and work on the whole image at the same time. Here, the artist is relatively close to the sitter for this informal full-length portrait (*see* pp. 44-47).

High and low viewpoints

Tall people seem even more statuesque if the artist paints them from a low viewpoint, while children look particularly small if painted from a high viewpoint.

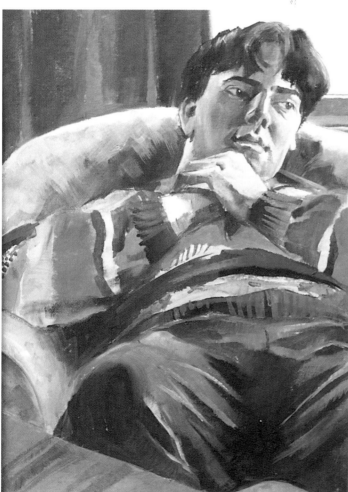

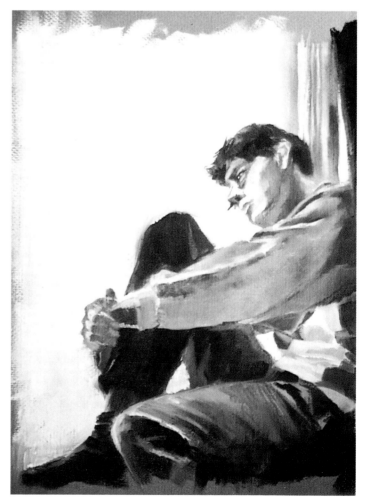

The sitter is occupied by a source to the right, which creates an unselfconscious mood.

The artist has moved further away from the sitter and adopted a low viewpoint.

41

THE BODY

NYONE WHO DOES a lot of life drawing and painting will know that the body is constantly surprising us. You may feel you have made studies of models of all ages, from all angles and in all lights, and yet the experience of each new situation remains an entirely unique one. There is no short route to mastering the structure and proportion of the body; you can only build up your understanding by practising continually. Make full-length sketches of people in the street, on the beach, moving and at rest, clothed and unclothed. Concentrate on the basic forms and how they relate to each other before you consider the details. Initially, you may find your heads are out of proportion, or that the arms seem too short, but the more you sketch, the more you will see how everything fits together.

Rapid sketches in pen and ink will help you understand the structure and proportion of the human body.

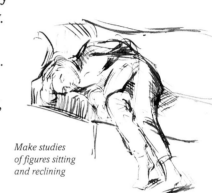

Make studies of figures sitting and reclining

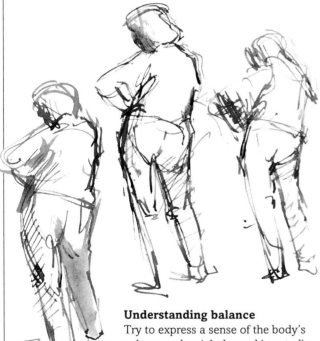

Understanding balance
Try to express a sense of the body's volume and weight by making studies of the same pose. Here, the weight is clearly concentrated on the left leg and a real sense of solidity and balance has been achieved.

Detailed study
In this warm, vigorous study for a full-length oil portrait (*see* p. 56), there is an almost intimate bond between the figure, the chair and the desk, with the composition well worked out. However, the artist has tried an alternative left arm and hand and it is interesting to consider why he was unhappy with the original positioning. Perhaps it tightened up the portrait in an unintended way.

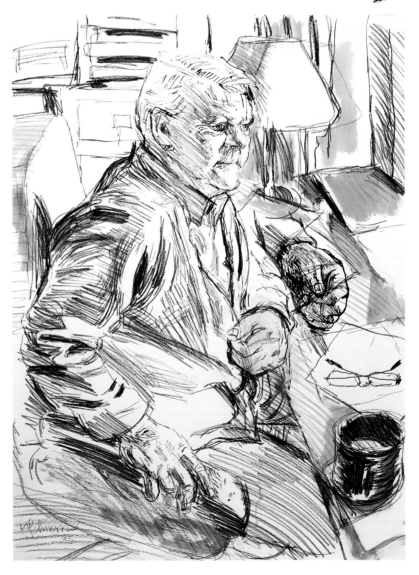

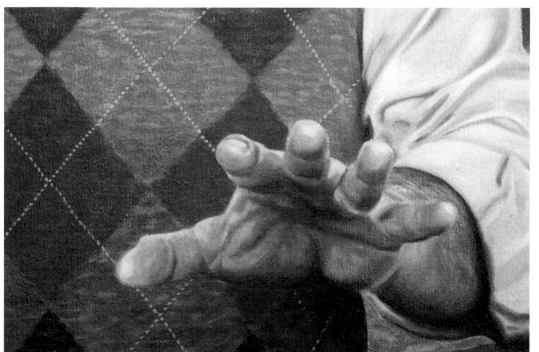

Painting hands

For every portrait you paint that includes a pair of hands, you will find a new position for them. Here, the subject is holding his hands out as if in the middle of expounding a theory. This creates an interesting challenge for the artist, not only because the hand is foreshortened (*below*), but also because the unusual pose needs to be painted well in order to look at all convincing. The palm is painted in shadow, which allows the fingers to be seen protruding. High-key greens and pinks have been used in the flesh tones to pull forward the hand from the figure.

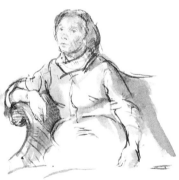

Hands and feet

It is worth taking time to consider hands and feet separately from the rest of the body. Draw and paint detailed studies from life, using your own left hand if you are right-handed, and your own bare feet. You might also copy images from illustrations of the works of well-known artists.

If you are preparing for a three-quarter length or full-length portrait which features hands or feet, make fully modelled studies in oil colour.

Make fully modelled colour studies of hands held in various positions.

Seated figures

The seated figure is a common subject for portraiture. Make studies in which you try to capture the way the proportions of the figure alter as the body weight is adjusted.

Paint studies of feet, both in pairs and singly.

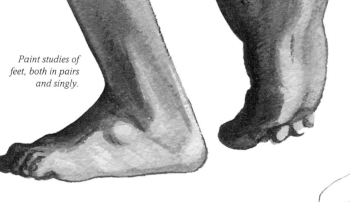

Foreshortening

If you are drawing someone who is sitting a short distance away and their arm or leg is extended towards you, this part of their body will appear proportionately much larger than the rest. This effect is known as foreshortening, and is useful to bear in mind when you are working, for it is easy to fall into the habit of drawing what you think you should see rather than what you actually see.

EXPRESSIVE HIGH-KEY COLOUR

THIS FULL-LENGTH study of a pensive, red-haired woman is an example of alla prima painting on a white ground. The artist has incorporated a high-key palette of bright colours, with warm oranges and cool blue-green tints predominating. Their true colours are revealed against the white ground and this is particularly effective where the paint has been used thinly. The warm colours are concentrated around the head and hair, forming the focus of the work. The artist constantly exploits complementaries, first laying down a fierce, vibrant colour, then tempering it with its cool complementary. The style of painting is characterized by loose, expressive brushwork for both the thin, transparent colours and the thicker, more opaque ones.

Warm orange and red are complementaries of cool green.

1 ▶ Sketch out the face and figure with a wash of Prussian Green and Yellow Ochre using a small sable brush. Stand back from the canvas as often as necessary to assess the body proportions. The loose nature of this preliminary mark-making will allow you to keep your options open as the figure begins to emerge. Roughly draw in the shapes of the eyes, eyebrows and nose.

2 ▶ Use a small round bristle brush to block in the hair with well-diluted Cadmium Orange. Indicate the planes of the face with broad strokes of thin pinks and greens, keeping the tonal range fairly close.

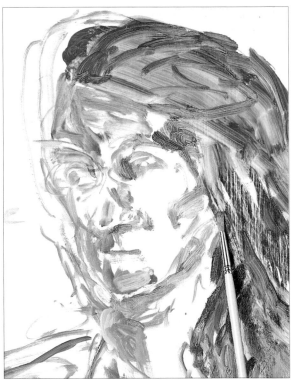

3 ▲ Use loose, sketched brushwork to fill in the flesh tones of the hands with a small round bristle brush. Overlay darker tones with opaque pale violets to suggest form.

4 ◀ Now pay attention to the foreground still life. Sketch out the lines of the desk, books and mugs before rapidly blocking in colour. Use the end of a paint brush to delineate the curves of the mug's handle. Keep detail brief so the foreground objects do not compete with the central focus of the sitter's face and hair.

5 ◂ Such relaxed brushwork and improvisations with colour may not always be successful. Correct any errors by scraping off the paint with a palette knife or wiping the area carefully with a rag dipped in solvent. You can then rework the area with fresh paint.

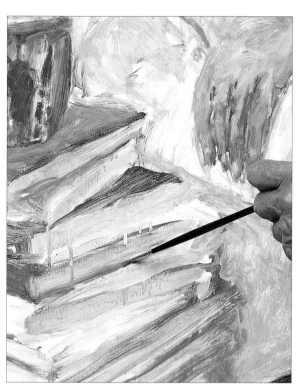

6 ▴ Use a small sable brush, such as a size 2, to paint lines of dark red and green for the edges of the books. Apply thick, broad strokes of opaque colour for the green of the table, using a large filbert bristle brush. These lines of deep, rich colour, in addition to the dark red of the mug, will help establish a pattern of dark tone in the lower half of the portrait.

7 ◂ Use blue-greens to cool the shadows of the fingers and to suggest the knuckles, before colouring the lighter areas with warm oranges and pinks. Work up the hands to completion before turning to other sections of the portrait. For the fingernails, use a small sable brush to apply single strokes of pale opaque pink, avoiding any precise detail.

8 ▸ Switch to a small round bristle brush to apply thick oranges and yellows to the hair. Keep brushwork loose and fluffy to emulate the way the hair naturally waves and falls. Apply a well-thinned layer of pink to the background, working briskly so that the whole surface is covered as quickly as possible.

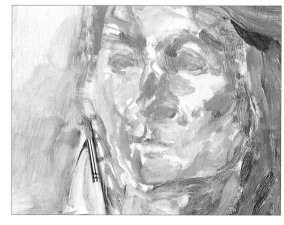

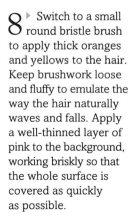

TIPS

● Well-diluted paint gives you a freedom and immediacy normally associated with watercolour. It removes the temptation to overwork during the early stages and allows you to cover the whole surface area of the canvas very rapidly.

● Applying thin paint to a white ground gives high-key colour a particular clarity, for the ground shines through and shows the true purity of each colour.

● When working alla prima, do not do too much "wet-in-wet" overpainting, otherwise there will be a tendency for your colours to become muddy.

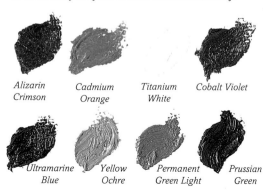

Alizarin Crimson *Cadmium Orange* *Titanium White* *Cobalt Violet*

Ultramarine Blue *Yellow Ochre* *Permanent Green Light* *Prussian Green*

FORM

The way in which the painting has been made shows a somewhat unconventional approach to form. The image emerges from a series of sketchy, superimposed brushstrokes without any preliminary tonal modelling. There is no solid form as such, more a highly coloured mosaic which, as you look at it, resolves itself into the figure of the young woman.

COLOUR

The approach to colour pays homage to Renoir and Bonnard, with orange, pink, lilac and blue-green predominating. The high-key colours and loose, fluffy brushstrokes give the work a warm, relaxed feel.

MEANING

The model appears abstracted, as if lost in her own thoughts. The portrait, with its focus on the orange hair, reminds us of the way we look at other people through the focus of our own preoccupations or desires.

9 ▲ Steadily build up colour in the arms, avoiding meticulous blending but working wet-in-wet with a range of pink, blue and yellow tints. Mix Titanium White and Cadmium Yellow for the highlights, stroking on the opaque colour loosely using a small round bristle brush.

10 ◀ Paint the beads with thick dabs of Cadmium Orange using a medium-sized round bristle brush. The curve formed by the string of beads draws the eye back to the head, completing the central area of vivid colour and strong tone. Work up the skin tones of the chest with chunky, dappled strokes of lilac, orange and blue-green.

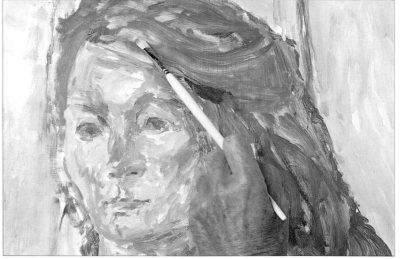

11 ◀ Use a medium-sized filbert bristle brush for the long, gentle strokes of the calves. Paint the shadows with blue-greens and use thick yellows and pinks for the areas that catch the light.

12 ▲ Add rich highlights of Cadmium Yellow and Cadmium Orange to the hair using a small filbert bristle brush. Scraped effects, achieved with the end of a paint brush, add detail and texture to the hair.

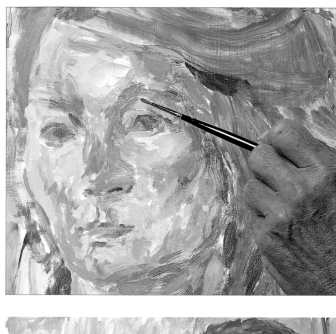

13 ◀ Use a small sable brush to suggest form around the nostrils, eyesockets and lips, without defining the lines too boldly. Work carefully, keeping brushwork light and deft.

14 ▶ Finally, apply a second layer of thin colour to the background, tinting the pink with a little Cadmium Yellow. Apply broad strokes with a large filbert bristle brush.

Full-length figure with red hair

The finished portrait shows how an improvisational technique can allow expressive patterns of colour effects gradually to emerge. The orange-reds of the hair are echoed in the background, which moves from warm pinks at the head to cooler purples and lilacs at the legs.

The mane of red hair is the most lively part of the portrait, the brushstrokes of rich colour flickering in a blaze of orange-red.

The white ground glows through the thin paint of the dress and enhances the purity of the greens and yellows.

The cool lilacs of the lower background warm the skin tones of the legs while echoing the violets in the foreground details.

The sitter's left foot has been left unfinished, adding to the sense of spontaneity in the portrait.

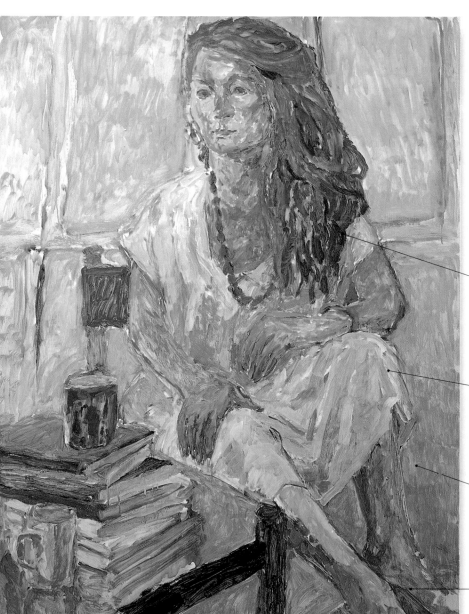

Hans Schwarz

Materials

Size 2 round sable brush

Size 3 round hog hair brush

Size 8 long filbert hog hair brush

Size 6 long filbert hog hair brush

Size 4 long filbert hog hair brush

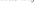

Palette knife

INTERPRETATION & MEANING

IN THE DESIRE to come to terms with the technical skills required for painting oil portraits, it can be easy to lose sight of other equally important considerations. When we work on a portrait, we should be aware that every choice made in relation to mood or atmosphere, composition and colour, background and setting, will have an impact on the meaning of the work. The meaning of a portrait, or the message it puts across, may well in part arise from the intuitions you get while actually painting. However, it is also the direct result of conscious decisions you have made in the setting up of the portrait. Try to work out exactly what you want to express in your work before you begin, and consider how a proposed change to the background or setting might affect how you interpret the painting, and how it is going to be perceived by others. It can be a useful exercise to take photographs of your sitter against different backgrounds and in various poses as these may help you decide how best to set up your portrait.

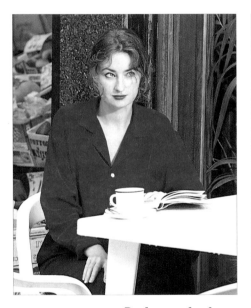

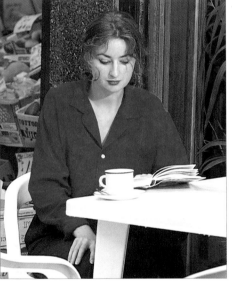

Creating a context
By seating the sitter at a café table, the image is immediately placed within a narrative context. If we then chose to paint the sitter looking down at her book with her coffee in front of her (*left*), we would be suggesting a relaxed and self-contained situation, in which all the action is concentrated within the sitter.

Choosing a pose
The context of an image changes dramatically according to the pose. If the sitter looks up (*far left*), the image takes on the quality of a film still, and we are invited to speculate on the possibilities that her expression generates. We can only wonder if it is one of wariness, annoyance or distraction, for the subject of her attention remains a mystery.

Background colours
Often, a particular background is selected for the vivid colour contrasts it sets up with the clothing and skin tones of the sitter. Here, the warm flesh tones stand out well against the cool, dark tones of the ivy, and the richly saturated red of the blouse perfectly complements the bottle-green foliage.

Eye contact
The direction of the sitter's gaze is an important clue to the message an artist wishes to get across. The sitter seems bemused (*right*), her face turned a little from the viewer and her eyes only half focused on some distant object. Alternatively, the head is held high and the spectator is fixed by a challenging, penetrating gaze (*far right*).

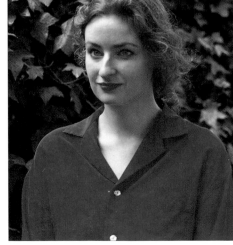

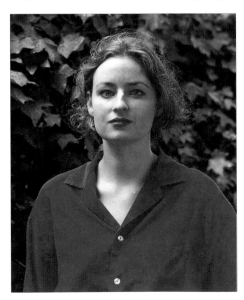

Too Much on Her Plate

The café setting in this painting by Mick Rooney, RA, is universally recognizable. Slightly down-at-heel but with pretensions to respectability, the interior has the feel of a stage set. We speculate on the nature of the relationship between the central figure with the fruity hat and the character who sits facing her. He is jabbing his knife at her, as if to emphasize a point, and this is underlined stylistically by the sharp silhouette of the knife against the yellow table top. The woman appears untroubled by him, as if the great confection on her head offers protection from any threat. Although she seems to be the one with too much on her plate literally, most of the characters in this little drama might be said to be suffering from the same problem.

Still life

The painting contains a number of vignettes, including this still life arrangement on the bright yellow table top. The vase, the bottle, the sugar bowl and the ashtray cast precise shadows and these seem to indicate the light source. However, the source of another shadow falling across the table is unclear. Such ambiguities add to the strange mood of the painting.

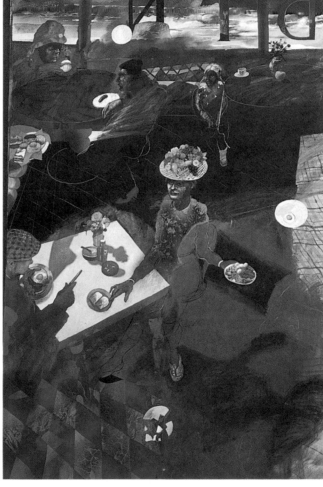

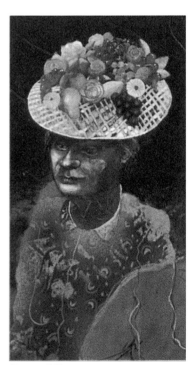

Girl with pigtails

The young girl with pigtails is set apart from the action in the café. There are references to the central woman in her neat collar and in the way her dress is painted, but the girl is, as yet, untroubled by the eccentricities of the older character.

Diamond shapes

The painting of the floor includes areas in which the artist has pressed pieces of scrunched-up fabric into the wet paint to create an unusual texture. These are like traces of some former incarnation of the space and have been partially overpainted with the red diamonds, as if to suggest that the café floor is itself only temporary, too.

Central figure

The woman at the centre of the composition is absorbed in her own thoughts, quite unintimidated by the gesticulations of her companion. She seems equally unconscious of the extraordinary still life arrangement on her hat, even though it may only be her upright posture that keeps it on her head at all.

COSTUME & DRAPERY

ARTISTS OFTEN TURN to the costume and drapery aspects of portraiture with a measure of relief after the rigours of painting the flesh tones. Indeed, there is often a sense of relaxation in the drapery painting, with loose, easy brushwork and vibrant colour effects. If you are setting up your portrait in a particular way, you may wish to decide what your sitter should wear. On the other hand, a portrait often reveals a greater accuracy of character and spirit if you allow the sitter to select his or her own clothing. However you proceed, the appearance and texture of costume and drapery will play an important part in the impact of the portrait.

Texture and pattern
The clothes your sitter wears and the accessories that go with them can be a rich source of texture, colour and pattern.

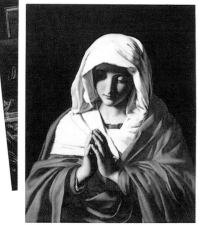

Postcard reference
Refer to illustrations from the history of portrait painting for wonderful examples of costume and drapery painting. These range from the ornate and highly intricate patterning featured in some early portraits to the intensity and vigour of costume by El Greco or Van Gogh.

Establish the shape of the collar in white

Scratch out the lines of the lace patterning

Sgraffito
This collar, after Rembrandt, shows a simple method of creating intricate detail. Lay down the dark background colour and allow it to dry before you add the lighter colour of the collar or scarf. While the paint is still wet, scratch the lacework design through it, using the sharpened end of a paint brush handle or a knife.

Modelling wet-in-wet
This study after El Greco shows an unusual but effective method of painting drapery. After the initial sketching in Burnt Umber has dried, a thin uniform film of translucent crimson is applied. The subsequent modelling of tones is made while this layer is still wet, with transparent colour used for the shadows and opaque white used for the light tones. The result is loose, rugged-looking drapery.

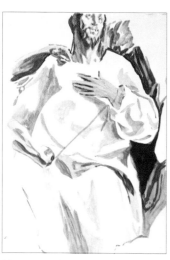

The image is sketched in with Burnt Umber

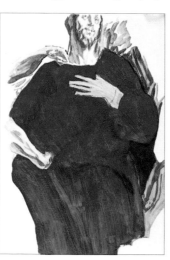

A thin transparent crimson is added

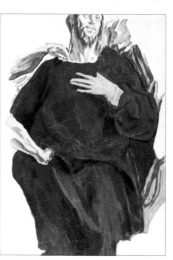

Darker transparent tones are applied

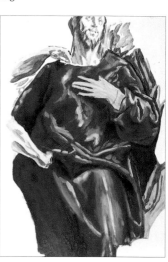

Opaque white is used for the modelling

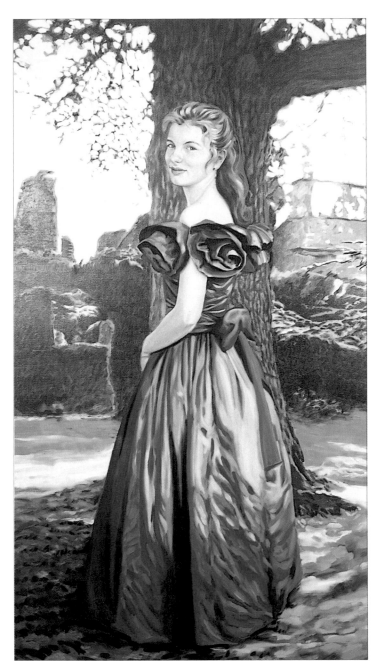

Glazing effects

This rich purple dress has been painted in two stages. The shape and form of the garment has been modelled monochromatically in pale blue and allowed to dry thoroughly. A translucent purple glaze has then been painted over it, giving a deep resonance to the colour and a dimensionality to the costume.

The brushstrokes used to paint the form of the dress are loose and direct, with very little blending.

The deep, dark tones of the glaze colour give depth to the modelling of the flower shapes around the shoulders and arms.

The patterning is painted in white

Rich patterning

If you are painting clothing with a rich patterning, begin by modelling the overall form and shape of the garment before you add the lines of the patterning. To retain the purity of the overlaid colour, you can paint the patterning in white first, allow it to dry, and then add the required colour. The final stage suggests the characteristic woven texture of the brocade fabric with delicate touches of Titanium White.

A layer of red is added

ACCESSORIES

The kinds of accessories people wear give clear clues to their character. Glasses, earrings, brooches, rings, cuff-links, tie-pins and bracelets can be great revealers of personality. If your sitter wears glasses, consider how you want to paint them, for your approach will affect the tone of the portrait.

Glasses worn high on the bridge of the nose become an inseparable part of the face.

Glasses perched on the end of the nose form a barrier between sitter and viewer.

A contemplative mood is created when glasses are treated as a prop.

PAINTING IN LAYERS

THIS PORTRAIT WAS COMMISSIONED to honour the retirement of a distinguished headmaster. It is a formal work, showing the subject in his robes and in the school setting, but at the same time it is an attempt to focus on the humanity of the man himself. In preparation, the artist made a series of charcoal drawings and small oil studies of the head and shoulders. He also took a number of photographs for reference. For the portrait itself, an indirect, layered technique has been used, with finely blended brushwork and light glazing. Close attention has been paid to the details of the background and costume. During the course of several sittings, the figure emerges with a strong, solid presence.

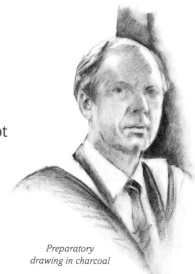

Preparatory drawing in charcoal

Reference material
For a commissioned portrait of this kind, it is very helpful to take photographs of your sitter from different angles and in a variety of lights and settings. There may also be areas of the painting, such as the background, which you may prefer to work up initially from photographs rather than from life.

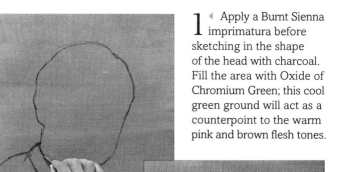

1 ◄ Apply a Burnt Sienna imprimatura before sketching in the shape of the head with charcoal. Fill the area with Oxide of Chromium Green; this cool green ground will act as a counterpoint to the warm pink and brown flesh tones.

2 ▲ Build up the form of the face with Titanium White, using a medium-sized filbert bristle brush and a dry brush technique. Stroke the ridges of the canvas with paint to create half-tone effects. Gradually strengthen the depth and opacity of the white so that the shape of the face emerges more clearly; then leave to dry.

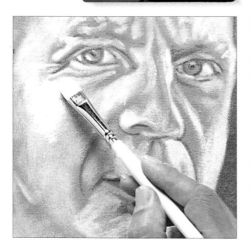

3 ◄ Mix flesh tones using touches of Cadmium Red and Cadmium Yellow Pale in Titanium White, adding Burnt Sienna for the deeper tones. Where the tones need to be cooler, use a little Winsor Blue or Green. At the same stage, give definition to the eyes with a small round sable brush, using Burnt Sienna for the outer ring of the iris and a touch of Cadmium Yellow Pale towards the pupil. This will give a useful early focus to the painting.

4 ▶ Use a similar technique for the hands as for the head, sketching in the modelling over the green ground with Titanium White. Fill the brush with the white paint, then wipe it off – this will leave enough residual paint in the hairs to allow you to use the dry brush technique to advantage. Once the white has dried thoroughly, paint over it with flesh tones of a slightly thicker consistency.

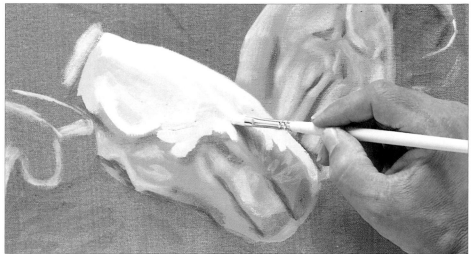

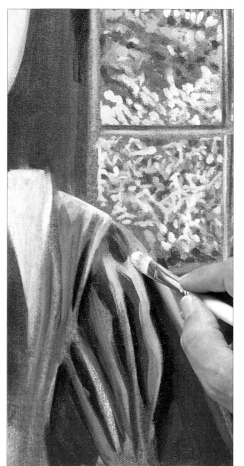

5 ◀ Use a translucent mixture of Burnt Sienna with a touch of Winsor Blue and Permanent Rose to lay down the shadows of the suit and gown. Establish the lighter areas with opaque greys, using a medium-sized filbert bristle brush, such as a size 6. Carefully work up tone and colour before allowing the areas of costume to dry.

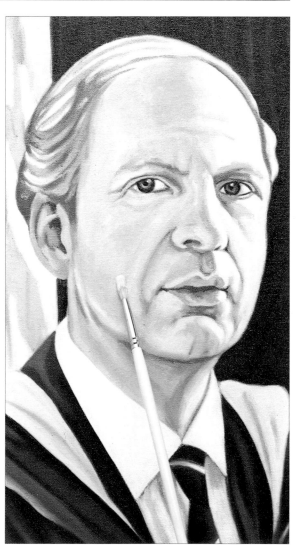

6 ▶ Now resume work on the head. Blend the flesh tones to the point where there is a general resolution of the main areas of light and shade. You may find that the tones need to be quite varied in order to achieve a lifelike, rounded modelling. Once this is completed, let the paint dry.

7 ◀ For the background areas, use translucent mixtures for the darker, shadowed areas and opaque mixtures for the light ones. A light mixture of Titanium White, Cadmium Yellow Pale and Winsor Green is ideal for the bright foliage. Apply touches of colour with a small filbert bristle brush, such as a size 2.

COMMISSIONS

When you are working to commission, you need to establish at the outset what your fee will be and how you would like to be paid. Then you can get on with the job of painting the portrait.

SETTINGS

You may wish your sitter to come to your studio, or you may prefer to paint your sitter in his or her own home environment. If you work at your subject's home, you will probably get a clearer and broader picture of them. You will also have the opportunity to paint them against a more personal and relevant background.

PAINTING STAGES

If you are painting in stages, your sittings should correspond to those stages and you will need to allow enough time between sessions for the paint to dry. If, on the other hand, you are working directly and into the wet colour, you can arrange to paint your sitter on consecutive days. Set up at least one sitting for painting the final modifications and details.

8 ▲ Apply an overall glaze to the suit and robes, using Burnt Sienna, Winsor Blue and Permanent Rose mixed with oil painting medium. Use a large filbert bristle brush, such as a size 10, to brush on the colour. The glaze will deepen the tone and give the blues and greys a rich glow.

9 ◀ Make any final adjustments to the clothes and drapery, such as the touch of light on the tie. Apply a mixture of Titanium White and Winsor Blue with a small round sable brush.

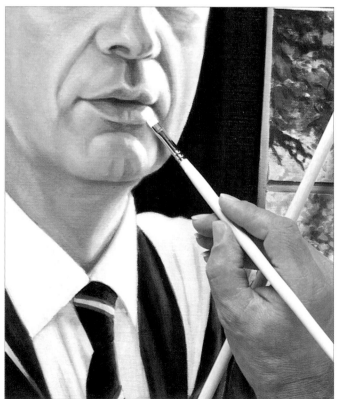

10 ◀ Make sure the paint on the head is completely dry before adding a very pale glaze to the area. Use a touch of transparent flesh colour in oil painting medium for a subtle effect. Once the glaze has dried, you can pick out any final details, such as the sunlight on the right-hand side of the bottom lip.

11 ▲ Using a small round sable brush, such as a size 1, paint a tiny highlight of Titanium White in the pupil. If any area of the canvas is still wet, rest your arm on a mahlstick as you work.

12 ▸ If your sitter wears glasses, it can be difficult to decide whether to paint him wearing them or not. One solution is to paint him holding a pair. Here, the reading glasses make an interesting detail at the bottom edge of the painting. Use a small round sable brush to pick out the bright, delicate lines of the wire frame.

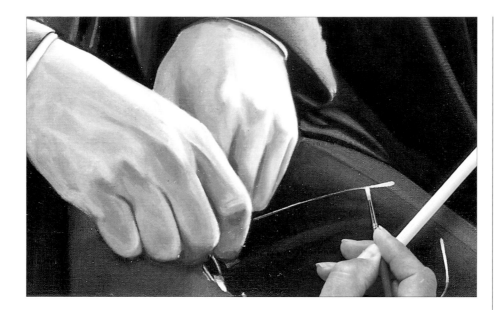

Materials

Charcoal

Size 2 long filbert hog hair brush

Size 1 round sable brush

Size 4 long filbert hog hair brush

Size 6 long filbert hog hair brush

Size 10 long filbert hog hair brush

The foliage is built up in layers. The darker areas are painted before the lighter tones, and then the touches of high-key colour are added.

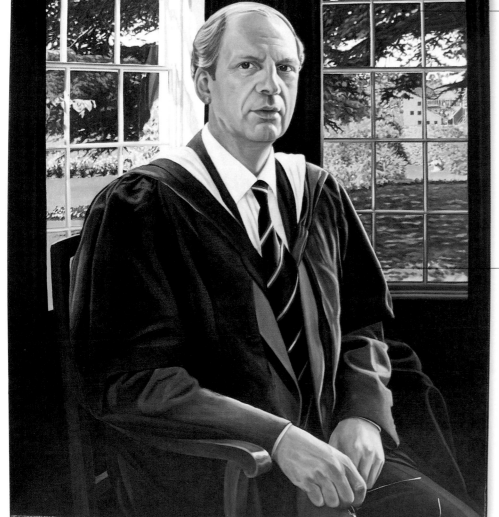

Portrait of B.T. Bellis, The Leys School
In the finished portrait, the play of light is crucial to the way the work is perceived. Side light from a source on the right falls across the right side of the face as we look at it. This accentuates the features, giving a rugged look and strengthening the head as the central focus of the work. The head is also brought forward by the dark tones of the curtains immediately behind it.

A transparent purple glaze is applied to the suit and the robes, deepening the tone and enriching the colours.

Ray Smith

MAHLSTICK

If you are unable to rest your arm or elbow on the edge of the canvas because the paint is wet, use a mahlstick. This is a stick of light bamboo or aluminium with a soft leather pad at one end which rests on the canvas. A mahlstick allows you to keep your hand steady for painting while avoiding contact with the wet surface.

GALLERY OF FORMAL & INFORMAL POSES

A COMMISSIONED PORTRAIT does not have to be stiff and austere. On the contrary, many of the best portraits have an informality, even a tenderness, that shines through a relatively formal pose. Peter Greenham's painting of Mrs Dorothy Hall and Whistler's portrait of his mother are good examples. On the other hand, the painting of Bruce Kent by Hans Schwarz has an informality of pose and setting that is not at all at odds with the strength of character of the sitter. Each of these paintings demonstrates the symbiotic relationship between artist and sitter, with the sitter's character emerging through the filter of the artist's style.

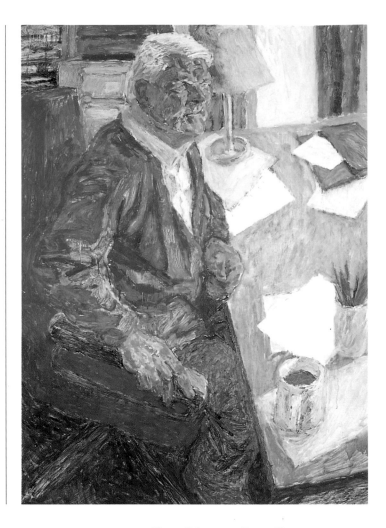

Hans Schwarz, *Bruce Kent,*
122 x 91.5 cm (48 x 36 in)
The vision and humanity of the sitter shines through this energetic portrait. It shows a man who is comfortable and relaxed at his desk in his warm red cardigan and red chair, but who nonetheless demonstrates his strength of purpose in the expression in his eyes and in the way his large hand grips the arm of the chair. The mug of coffee planted firmly on the corner of the desk roots the work in the everyday.

James McNeill Whistler, *Arrangement in Grey and Black, the Artist's Mother,* 1871, *145 x 164 cm (57 x 64¹/₂ in)*
The dark, solid shapes of the wall, dress and curtain give this portrait a formal poise and clarity. At the same time, there is a tenderness in the pose, with the head at a slight angle and the hands clasped together, and in the softness and warmth of the flesh tones set against the cool monochromatic tones of cap, dress and wall. There is a reflective, almost elegiac tone about this painting which makes it a source of meditation.

Kees van Dongen, *La Comtessa de Noailles,* **1926,** *197 x 132 cm (77¹/₂ x 52 in)*
There is an air of casual decadence about this portrait which combines with the relaxed style of painting to create a work of great immediacy and charm. The use of pure black is unusual – most artists use mixtures of other colours to obtain dark tones – but it works perfectly in conjunction with the creamy white of the subject's bare shoulders and shimmering dress. The slim figure of the countess emerges dramatically from the deep shadows of the background, her face proud and amused.

Tonal and colour contrasts are strong in this detail between the pale flesh tones and the deep red lips, choker and cheeks.

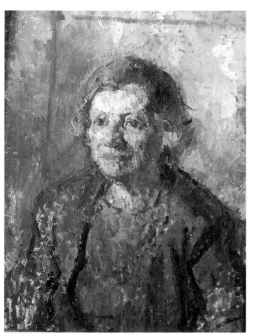

Sir Peter Greenham, CBE, RA, *Mrs Dorothy Hall,* **1960,** *51 x 41 cm (20 x 16 in)*
Peter Greenham's paintings always seem to bring out the warmth and humanity of his subjects. He has a soft, flickering style, in which small brushstrokes dart around the contours and features of the sitter and eventually become resolved into his sympathetic portraits. Here, the mobility of style, coupled with a searching observation, gives great life to a subtle work.

In this detail, a kind and intelligent face emerges from the enquiring, unblended brushstrokes.

Composing a Group Portrait

As soon as you put two or more figures together in a portrait you enter a complex world of human interaction quite different from that of the single portrait. With double or group portraits, a series of relationships is being set up on the canvas and the spectator will read these relationships in very specific ways. Whether you are using two or three figures to establish a particular narrative or co-ordinating a large family in a domestic portrait, you need to make clear decisions about composition.

The various stages of this group portrait demonstrate how comprehensive and careful your preparatory work should be.

Study in conté crayon

Colour sketches
In these preparatory studies, pencil, watercolour and crayon have been used to explore elements of the composition. This is an excellent way to master the forms of the images to be used and to make practical colour notes.

Pencil studies
Both small, swift pencil studies and detailed drawings of costume and accessories make useful reference material for painting the group portrait.

Detailed pencil and crayon drawing

Planning the composition
In this study, the artist begins to sketch out possibilities for the composition. At this early stage, there is a good sense of balance, but the background seems a little empty of figures. The hat worn by the lady on the left and the hair and clothing of the standing figure on the right have been established as the main areas of dark tone.

This self-possessed figure makes a youthful contrast to the older characters.

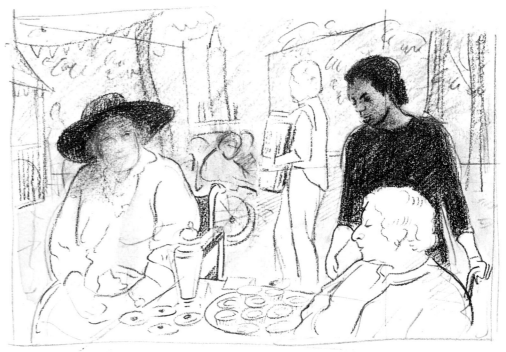

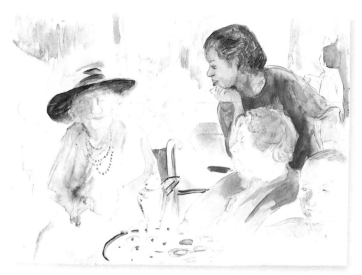

Watercolour study

A more highly resolved watercolour study shows how the composition has developed. The standing woman now leans over to talk to the woman in a hat, while a foreground figure has been added in the right-hand corner. The artist now considers the inclusion of several background figures, perhaps to fill out the composition.

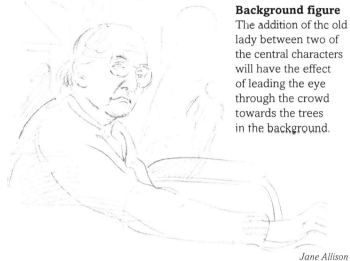

Background figure

The addition of the old lady between two of the central characters will have the effect of leading the eye through the crowd towards the trees in the background.

St Pancras Garden Party

The final composition is a richly painted image full of life and activity. The bright, saturated colours and warmly observed figures give us a sense of being present at a real garden party. Here, there is neither overblown sentiment nor over-cool detachment; more a feeling of showing a genuine human situation exactly as it is.

Jane Allison

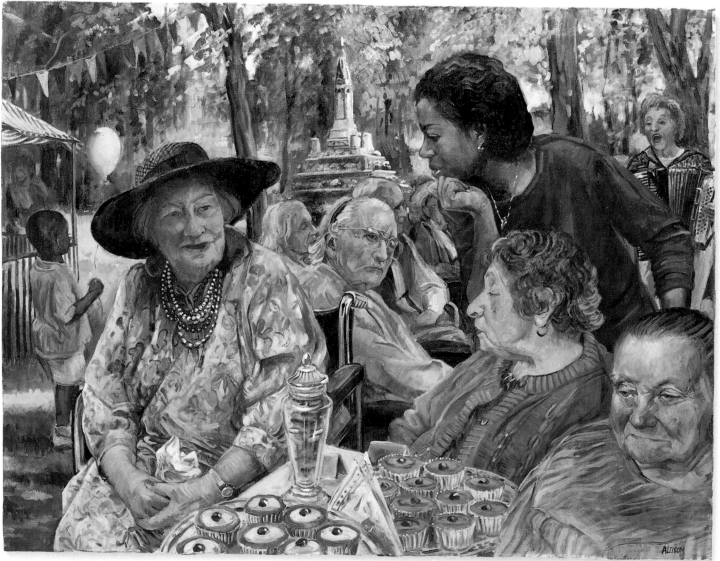

DRAMATIC LIGHT

Drawing your composition
After toning the canvas with a light wash of Raw Umber, rapidly sketch the outlines of the composition in a mix of Venetian Red and Raw Umber using a small sable brush.

THIS DOUBLE PORTRAIT is a central composition in which the eye is drawn into the frame past the girls and to the open window. This is the source of the light which pours into the room, highlighting the girls' limbs and flooding the floor like a stage set. Indeed, there is a sense of the situation being consciously set up to celebrate these particular qualities of the light. The painting is completed in one session and does not need to be overworked to make its point. The artist has left out unnecessary detail, subdued the tones and adjusted the colours to achieve a soft, warm effect.

1 ◄ Mix your colours from a palette of Raw Umber, Indian Yellow, Yellow Ochre, Cadmium Yellow Pale, Venetian Red, Ultramarine Blue, Titanium White, and Viridian Green. Use a medium-sized short flat bristle brush to cover each area of the canvas with deft strokes of broken colour.

2 ▲ Establish early your areas of light and shade and gradually build up tone and colour, strengthening darker tones by working wet-in-wet with a long flat bristle brush. The shadows already contrast powerfully with the sunlit areas.

3 ▲ For the foliage in the garden outside, thin your colours with turpentine and apply delicate strokes of colour with a small sable brush. Pale, dappled purple-greys and blues best express distant light and colour.

TIPS

• Children can be restless sitters, so keep sessions as short as possible and use photographs and sketches for reference.

• If you prefer a layered technique, you can use well-thinned acrylics for the underpainting – they are fast-drying and will save you time.

4 ▶ Much of the theatrical atmosphere of this work is achieved by the strong sunlight dazzling the faces and limbs of the girls. Lighten your flesh tints with Titanium White and Cadmium Yellow Pale for opaque highlights on the faces, arms and legs. Capture the gentle contours of the children's limbs by applying strokes carefully with a small sable brush.

5 ▷ The bold definition of the window frame holds our attention in the central area of the composition. The effect is softened by the gentle curves and light texture of the curtains. Apply thick dashes of yellow and white to the edges directly lit by the sun. A small sable brush allows the control and precision necessary for the finer highlights.

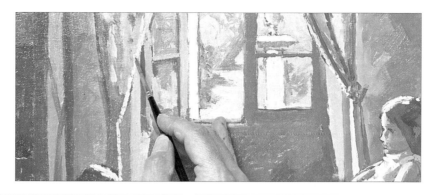

Materials

Size 2 round sable brush

Size 2 short flat hog hair brush

Size 3 long flat hog hair brush

Size 5 short flat hog hair brush

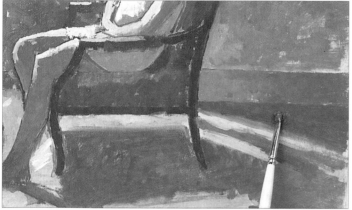

6 ▲ Use a short flat bristle brush, such as a size 2, to paint the deep shadows of the floor with long, flat strokes of dark browns and muted purple-greys. These areas of deep shade act as smooth, solid anchors in the lower half of the composition and contrast dramatically with the streaks of sunlight below.

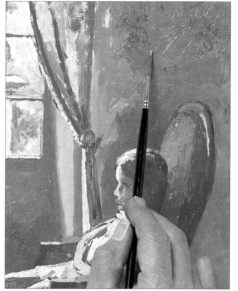

7 ◁ Blend the broken colours of the wallpaper for a sleek, flat appearance, before picking out final highlights with a small sable brush. Keep details, such as the patterning on the wallpaper, to a minimum.

Double portrait with dramatic light
The finished painting shows the successful effect of combining muted yellows with complementary lilacs and purple-greys. The bright light seems to hold the two girls in its warmth and clarity, expressing a quality of timelessness in childhood. The work speaks of a single, casual moment in time, when, for an instant at least, time is suspended.

James Horton

The soft brushwork on the arms expresses the gentle contours of the children's limbs.

The strong squares of the box and window form a central focal point in the painting.

Deep shadows contrast with the areas of sunlight.

FURTHER STUDIES

Use your finished work as a study for more detailed paintings. This version, painted on a larger canvas with finely blended brushwork, is much sharper in detail. The girl's raised arm adds a sense of immediate action and energy.

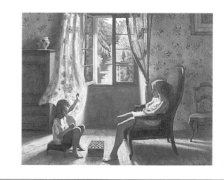

GALLERY OF DOUBLE PORTRAITS

THE DOUBLE PORTRAIT invariably invites speculation or suggests observations about the nature of human relationships. Settings become enormously important, containing clues to guide our thoughts and reactions. The themes and relationships at work in these four portraits are quite varied. We see the self-possession of children at play, the intimacy of the relationship between mother and child, a portrait of the artist's parents, which is at once clear and enigmatic, and two men in an unidentified space lit by artificial light. All four portraits share that quality of attraction which invites our curiosity.

John Singer Sargent, *Carnation, Lily, Lily, Rose,* 1885-6, *174 x 153.7 cm (68¹/₂ x 60¹/₂ in)*
The artist has painted the girls during those twilight moments when the atmosphere is at its most dreamlike with the combination of natural and artificial light. Each girl is absorbed in the lantern she holds, yet there is a camaraderie in this shared activity which gives the painting warmth.

Neale Worley, *Harold and Dennis,* *76.2 x 91.5 cm (30 x 36 in)*
The undefined relationship between the two figures makes this work particularly interesting. What we see clearly is how their physical proximity brings out the character of each man. The foreground figure faces the artist and the spectator, and there is a degree of humanity expressed which invites a dialogue with us. The second man looks down, his face a deeper tone, as if closer to the shadows.

There is an ease and an assurance in the artist's brushwork which gives the hand a great deal of life and vigour. We can imagine it moving up to express a point or to bring the cigarette up to the face.

Ghislaine Howard, *Mother Embracing her Child,* *119.5 x 94 cm (47 x 37 in)*
The subject of mother and child has been a central one in the development of oil painting. Here, we see the theme approached from a completely informal point of view. There is an immediacy and a joy about this work which truly expresses the mother's love for the feel and the smell of her baby. The warmth and informality of the relationship is shown as much by the style of the work, with its rich charcoal drawing and loosely sketched brushwork, as it is by the subject itself.

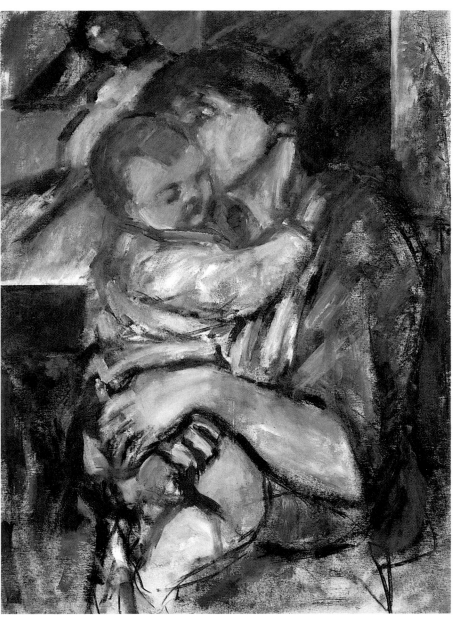

The intimacy of the bond between mother and child is expressed in the angle of the mother's head, leading us to wonder what she is whispering to her child.

David Hockney, RA, *My Parents,* **1977,** *182.9 x 182.9 cm (72 x 72 in)*
David Hockney's portrait of his parents has the characteristic crispness of all his painting. He has set them up with the clarity of a still life by Chardin, a book of whose work lies on the shelf, or an image by Piero, whose painting we see in the mirror. We wonder about the nature of their relationship and indeed of their relationship with their son. His mother gazes directly at the painter, but his father has moved his chair to a position that suits him and he is entirely absorbed in his book. Two very distinctive characters emerge.

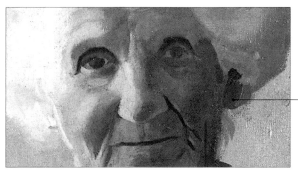

The artist's mother is alert and kindly in this detail; she faces the artist directly, giving him her full attention.

Texturing oil paints
You can experiment with different textures by stirring sand or sawdust into your paints. Be sure to use a rigid support.

ALTERNATIVE TECHNIQUES

EVERY ARTIST MAKES a unique contribution to the medium in which he or she works, and it is a tribute to the extraordinary variety of oil paint effects and techniques that we can immediately recognize the individual styles of so many different painters. You will find that as you continue to paint portraits, you quite naturally develop your own technical and stylistic approach. This will lead to your using oil colour in ways that no one else has done. Here, two alternative techniques for making oil portraits are demonstrated. The first involves a simple sgraffito method on sand-blasted glass, and the second shows how a freeze-frame image from a video can inspire an unusual portrait.

Portrait study
This small sketchbook image was made in a few seconds with a fine-nibbed pen. Its simple lines are recreated in a portrait on sand-blasted glass (*below*).

1 ▲ Wash and dry a piece of sand-blasted glass and coat the sand-blasted side with Titanium White oil colour straight from the tube. Use a thin, flexible piece of plastic, such as an old credit card, to spread the paint evenly over the back of the glass to a depth of about one millimetre (0.04 in). Use the sharpened end of a brush handle to draw the image into the paint with a steady hand. Make sure you are scraping along the surface of the glass as you draw.

2 ▶ Allow the paint to dry completely; this may take a few days. Apply thick dark colour to the lines you have scraped out, using a large bristle brush.

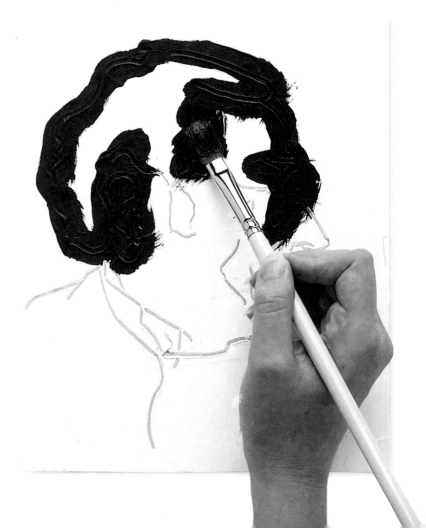

3 ◀ When the dark colour has dried, turn the glass over and you will see the lines of the portrait image against the completely uniform white ground. The sand-blasted glass gives a soft, slightly grainy effect to the lines. The particular quality of the image depends to a large extent on the thickness of the glass, which can give an attractive greenish or bluish cast to the work. "Back-painting" on glass is a traditional technique and you can make fully three-dimensional looking images if you wish. Always remember that you are painting in reverse, so you need to start with the highlights and light opaque tones and work back to the shadows.

OIL STICKS

Oil sticks, made from oil paints blended with waxes, are an excellent medium for painting full colour portraits. You can use them like crayons, but you will find they have a far greater intensity of colour and a more liquid feel. It is possible to paint into wet colour with an oil stick and retain the purity of the colour you have added.

Freeze-frame portrait
Electronic imagery can provide a stimulating source of inspiration for the contemporary portrait painter. In this monochromatic study, a textured gesso ground has been prepared on panel. This has then been sized and given a Winsor Green imprimatura. The image is painted in Titanium White using brushstrokes which imitate the flickering images of a video freeze frame. You can experiment with the colour controls on your television set to produce source images in highly saturated colours.

The picture frame is an integral part of the portrait; it echoes the dark, solid edge of a television screen.

GALLERY OF MODERN APPROACHES

THERE HAS BEEN a great diversity of approach to portraiture during this century. Advances in electronic imaging and other forms of instant visual communication have created exciting new possibilities for many painters. Howard Hodgkin is among those who best express their insights into character by using a non-figurative style, while artists such as Frank Auerbach continue to work directly from life, but in quite innovative ways.

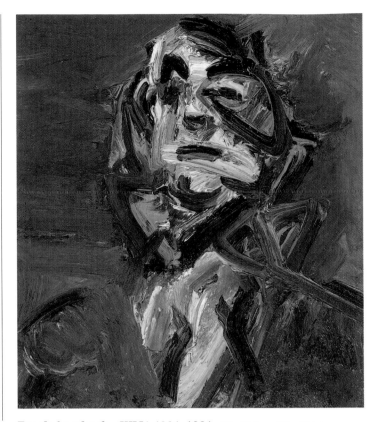

Frank Auerbach, *JYM1.1981,* **1981,** *56 x 50.8 cm (22 x 20 in)*
A unique approach to portraiture and a process of continual readjustment lie behind this work by Frank Auerbach. The artist uses the same few models repeatedly for his paintings; he knows them well and considers it important to see them in contexts other than the studio. By this means, he is able to build up a picture of his subjects that informs the painting sessions in the studio. Here, thick, loosely mixed oil colour is applied vigorously and swiftly to produce a portrait of astonishing immediacy.

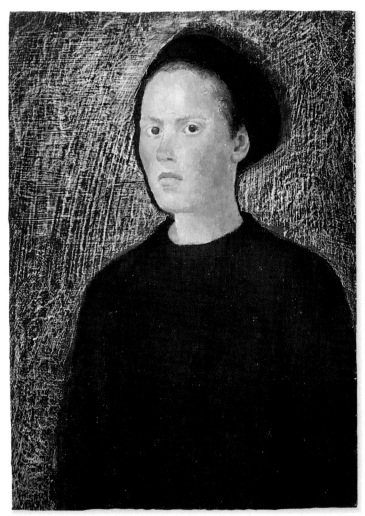

Patricia Wright,
Blue Self-Portrait, *23 x 16 cm (9 x 6¹/₄ in)*
In this self-portrait, Patricia Wright looks back at the viewer with a rather guarded expression. There is an air of wariness, as if she is uncertain about the outcome of this confrontation. She gives us few clues; her clothes are black and rudimentary in form, and her hair is pulled back under a cap. The background has been textured, overpainted and then scraped back, so that it becomes a powerful, almost aggressive feature of the painting.

A tension is set up between the sensitivity of the flesh tones and the coarse, textured background.

Max Beckmann, *Portrait of an Argentinian,*
1929, *125 x 83.5 cm (49¹/₄ x 32³/₄ in)*
*In Max Beckmann's paintings, the realities of life are
transformed into the stuff of legend, myth and metaphor.
His characters inhabit a strange, metaphysical world in
which the force of our unconscious preoccupations is
given dramatic expression. Something of this is revealed
in the pale, sensitive young man dressed in his dinner
jacket and poised on a chair. Beckmann has captured
a sense of uneasy nonchalance and a restlessness of
spirit that gives his sitter an enigmatic character.*

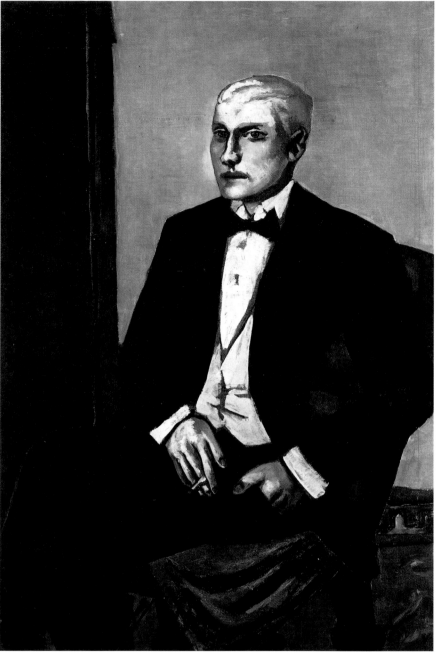

In this detail, the man's face is almost
white, his cheeks flushed pink and his
lips orange-red, suggesting a night
person always seen in artificial light.

Howard Hodgkin, *Mr and Mrs Stephen Buckley,*
1974-6, *73.3 x 107.3 cm (28³/₄ x 42¹/₄ in)*
*We can only guess from the free-floating forms and bright colours
of this abstract painting exactly what the artist wishes to say about
his subjects. A certain boldness and a ruggedness of construction
point the way to our interpretation of the double portrait.*

The circular crimson
brushstrokes of this
detail have a vigorous,
scratched look,
creating a rugged
form that acts as
a gateway to the
dark space behind.

Varnishing & Framing

Varnishing a painting gives it some protection from dust, dirt and abrasion. The main difference between a layer of varnish and the layers of paint is that paint layers are permanent, whereas the varnish is removable. In future years, when the varnish gets dirty, discolours or degrades, it can be removed and new varnish applied. Oil painting varnishes generally consist of ketone resins in white spirit, and these are available as gloss or matt varnishes. Alternatively, you can use wax varnishes made from beeswax and white spirit, which provide good protection and give a lustrous appearance. Choose your frame with great care. A sympathetic frame will enhance a portrait, while an inappropriate choice can rob the image of its impact.

Your choice of frame will have a considerable effect on the look and mood of a portrait.

VARNISHING

Use a flat brush to apply two coats of varnish. The brushstrokes used for the second coat should be at right angles to those of the first. If you use a wax varnish, polish the surface gently when dry.

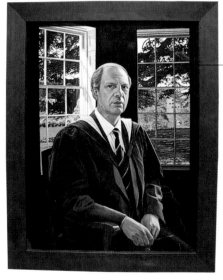

Allow the varnish to dry before applying the second coat.

Varnish

Frame mouldings
There are countless picture frame mouldings available commercially. You can also ask a good picture frame maker to create a unique frame for your portrait.

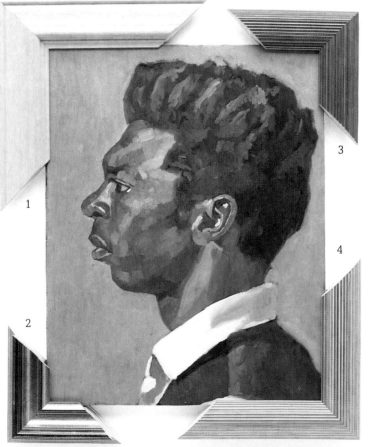

3

1

4

2

Choosing a frame
The best way to decide which style of moulding to choose for your frame is to experiment with prefabricated corners. Of those tried here, the heavy wooden frame (1) works best, its muted yellow emphasizing the blue in the background colour and enriching the flesh tones. The simple lines of the top left moulding (5) are also successful, but the red version (8) is less appropriate, its colour too strong for the subtle colours of the painting. Also unsympathetic are the two slim, dark mouldings (6, 7), for their scale has little effect on so striking an image. The chosen frame is bold and solid; it powerfully maximizes the impact of a highly dramatic pose.

The simple wooden corner (1) works better than the more detailed styles.

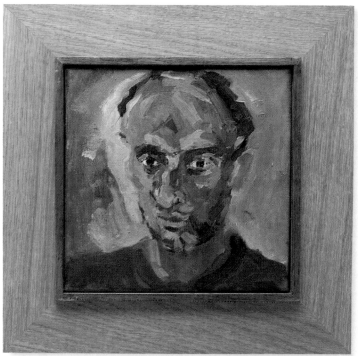

Creating a focus

The thick wooden frame is designed to focus on the intensity of the colour in this small painting, with the rich, natural texture of the wood enhancing the red ground. The square solidity gives the impression of the subject looking out of a window frame, which creates an intriguing mood of detachment.

Cardboard mounts

Many of the pencil and charcoal studies you have made on paper will deserve to be framed behind glass. A cardboard mount provides a visual bridge between the work and the moulding.

Sympathetic framing

The simple clarity of this portrait is well retained in the use of a flat wooden moulding. The grey stain echoes the earth colours used in the painting itself.

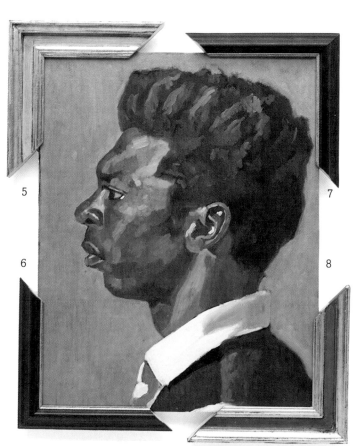

5
6
7
8

The dark corners look too thin for the chunky image and the red too overpowering.

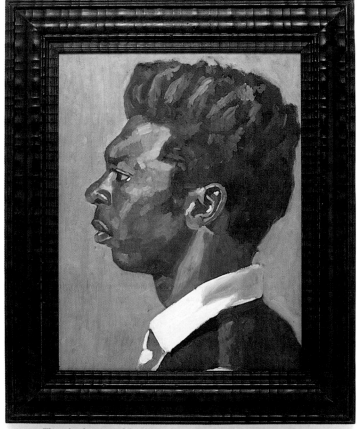

The ridged texture of the chosen frame echoes the dappled brushwork.

GLOSSARY

ACETATE Clear plastic film on which it is possible to draw in ink.

ADJACENT COLOURS Colours with some similarity in hue. A warm orange-red and a warm orange-brown might be juxtaposed in a painting to give a quite different kind of colour harmony to that achieved by using complementaries. The term also refers to any colour next to another one.

ALLA PRIMA Literally means "at first" and is a direct form of painting made in one session or while the colour remains wet. (As opposed to "indirect" painting in which the painting is built up in layers.)

BRISTLE BRUSHES Made from hog hair, these are brushes with stiff, coarse hairs which hold plenty of thick paint and retain their shape well.

BROKEN COLOUR Colour that has been changed by mixing with another colour or affected optically by the juxtaposition or superimposition of another colour.

CHARCOAL Carbonized wood made by charring willow, vine, or other twigs in airtight containers. If charcoal is used for a preparatory drawing, the excess dust can be rubbed off the surface using a large soft-hair brush or a piece of doughy bread.

COLOUR HARMONY The balance and order of colour in a painting, created by the artist's manipulation of such effects as warm and cool colours, complementary colours and high-key and low-key colours.

COMPLEMENTARY COLOURS Opposite colours on the colour wheel of maximum contrast to each other, such as yellow and blue-violet, orange-red and blue, or magenta and green. In painting, if you were physically to mix two complementary colours together, you would get black.

DARKS Those parts of a painting that are in shadow.

DRY BRUSH TECHNIQUE A method of painting in which paint of a dry or stiff consistency is stroked or rubbed across the canvas. It is picked up on the ridges of the canvas or the texture of the painted surface, leaving some of the colour below still visible.

EGG TEMPERA Painting medium consisting of pigment and distilled water bound with egg yolk.

EPIDIASCOPE Projector for enlarging sketches or reproductions.

FAT-OVER-LEAN A fundamental rule for producing a sound paint structure. It applies to oil painting in layers, in which each subsequent layer of paint has its oil content increased a little by the addition of oil painting medium, in order that each layer is a little more flexible than the one beneath it.

FILBERT Bristle brush with a round toe and flattened metal ferrule.

FLAT BRUSHES Square-toed brushes with flattened metal ferrules.

FLAT COLOUR An area of colour of uniform, untextured tone.

FORESHORTENING The perspective effect that occurs when part of the subject is much closer to the artist than another part and appears large in comparison.

GESSO A traditional ground for oil painting on panel comprising animal glue (rabbit skin glue) and plaster of paris, chalk or whiting. Prepare the size in a double boiler using 70 grams (2½ oz) of size to a litre (2 pts) of water, apply this to the panel

and allow to dry. Stir in plaster of paris to a creamy consistency and apply several coats to the panel. Sand to a smooth finish and add a second coat of size to reduce the absorbency of the panel.

GLAZE A film of transparent or translucent oil colour laid over another dried colour or underpainting.

GROUND The surface on which colour is applied. This is usually the priming rather than the support.

HALF TONES Transitional tones between the highlights and the darks.

HIGH-KEY COLOUR Brilliant and saturated colour. Some oil colours, especially the transparent ones, are dark when used directly from the tube, so a little white can be mixed with them to give a saturated colour effect. Alternatively, such colours can be used thinly on a white ground for a similar high-key look.

HIGHLIGHT The lightest tone in drawing or painting. In oil painting techniques, white constitutes the lightest tone.

HUE This describes the actual colour of an object or substance in terms of its position on the colour wheel. The hue may be red, yellow, blue, green, and so on.

IMPASTO A thick layer of paint, which is heaped up in ridges to create a heavily textured surface.

IMPRIMATURA A thin overall film or stain of translucent colour over a white priming. This is applied before the artist begins to paint. It does not affect the reflective qualities of the ground, but it provides a useful background colour and makes it easier to paint between the lights and darks.

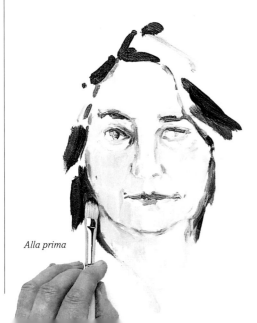

Alla prima

Oil colours

Grounds

LOW-KEY COLOUR Subdued, unsaturated colour that tends towards brown and grey. Tertiary colours are low-key in appearance and produce neutral hues similar in mood and tone.

MODELLING In painting techniques, indicating the three-dimensional shape of an object by the appropriate distribution of different tones.

MONOCHROMATIC PAINTING Painting in tones of one colour.

OPAQUE PAINTING The opposite of transparent painting, whereby lighter tones are produced by using white paint and not by thinning the paint.

PALETTE (i) Portable surface for mixing colours. Mahogany palettes are useful for portrait painting if you are working on a warm brown ground, because the mixed colours appear on the palette as they will on the canvas. (ii) The range of colours an artist chooses to work with.

PIGMENT Solid, coloured material in the form of small discrete particles.

PRIMING This refers to the preliminary coating laid on to the support prior to painting. A layer of priming protects the support from any potentially damaging components of paint and provides the surface with the right key, absorbency, and colour before painting.

PROPORTION The correct or appropriate relationship between the parts and the whole.

ROUND BRUSHES Brushes with rounded toes and round metal ferrules.

SABLE BRUSHES Soft, fine brushes made from mink tail hair. These are used for detailed brushwork or final touches and highlights.

SAND-BLASTED GLASS Glass sprayed with abrasives under pressure to make the surface translucent and finely textured.

SATURATION The degree of intensity of a colour. Colours can be saturated, i.e. vivid and of intense hue, or unsaturated, i.e. dull and tending towards grey.

SGRAFFITO A drawing or pattern-making technique of scratching through a layer of wet paint with a tool such as the sharpened end of a paint brush handle to reveal another, dry colour below it.

SIZE Rabbit skin or other glue used to protect canvas from the potentially damaging effects of oil in the paint before priming and to seal or reduce the absorbency of wooden panels. The binding material for gesso.

SOLVENT Any liquid in which a solid can be dispersed to form a solution. A resin varnish dissolved in an organic solvent like turpentine will harden after being applied as the solvent evaporates. Used widely as thinners or diluents.

SUPPORT The material on which a painting is made. Almost any surface can be used, but artists tend to use either a wooden panel or a canvas. These materials are available in a range of textures and weights.

TINT Colour mixed with white.

TONE The degree of darkness or lightness of a colour.

TONED GROUND An opaque layer of coloured paint of uniform tone applied over the priming before starting the painting.

UNDERPAINTING Preliminary painting, over which other colours are applied.

VARNISH Protective surface over a finished painting imparting a glossy or matt surface appearance.

WARM AND COOL COLOURS Generally, a colour such as orange-red is considered warm. In accordance with atmospheric or aerial perspective, warm colours appear to advance towards the viewer.

WET-IN-WET Working with wet paint into wet paint on the surface of the support.

Opaque colour mixes

A NOTE ON COLOURS, PIGMENTS AND TOXICITY

In recommending Winsor Blue and Winsor Green (which are trade names of the Winsor & Newton Company) we are recommending "Phthalocyanine" pigments; other artists' material manufacturers refer to them by their own trade names. These include Phthalo Blue and Green, Monestial Blue and Green and so on. Similarly, in recommending Permanent Rose we are recommending a "Quinacridone" pigment. If you have any doubts about which pigment you are buying, refer to the manufacturer's literature.

We have tried to avoid recommending pigments, such as the Chrome colours, which carry a significant health risk. Toxic pigments such as Lead White or Cobalt Blue should also be avoided when making your own colours. In the case of colours such as the Cadmiums, however, there is nothing commercially available which matches them for colour and permanence. But there is no danger in their use nor in that of other pigments provided artists take sensible precautions.

Solvents are damaging to your health, so always keep the lids of solvent jars screwed on tight and use only as much as you need. The long-term effects from inhaling the fumes of distilled turpentine and white spirit include loss of memory, the inability to follow an argument, and paranoia.

A NOTE ON BRUSHES

The brush sizes given here refer to Winsor & Newton brushes. They may vary slightly from those of other manufacturers.

Preparatory drawing

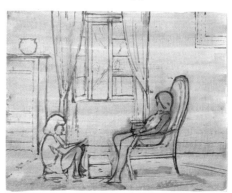

Imprimatura

INDEX

ACKNOWLEDGEMENTS

Author's acknowledgements
Ray Smith would like to thank everyone at Dorling Kindersley involved with the DK Art School series, especially my editor Louise Candlish and designer Claire Pegrum whose real interest in the project made them such an enthusiastic and efficient team. They were ably assisted by Margaret Chang and Dawn Terrey, with help from Ruth Kendall. Thanks to Alun Foster at Winsor and Newton Ltd for all his expert advice. In addition, I would like to thank all the artists who contributed to the book, including the Royal Academicians who kindly agreed to their work being represented and the young painters whose work was featured in the National Portrait Gallery BP Awards exhibition and who created some exciting new work for this book. Thanks also to Lord and Lady Renfrew and to B.T. Bellis and the Leys School in Cambridge for lending paintings and to John Butler for introducing me to Kees Van Dongen's "Countess". Finally I would like to thank my daughter Emily for letting me use some of her very early drawings.